IMAGES
of America

BRADENTON

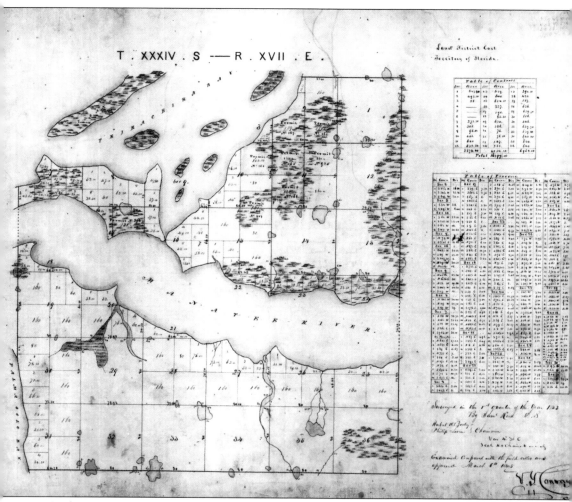

In this 1845 map, several plots are designated as pioneer properties. The map was hand drawn by cartographer V.Y. Conray. (Personal collection.)

On the Cover: Two women pose in front of Bradenton's most recognizable landmark, the city's municipal pier. In 1916, the board of trade recommended building the pier to draw tourists to the waterfront. The city passed a referendum for a $221,000 bond to finance the project, but it was defeated by public vote. The project remained in remission until 1926, when the Woman's Club of Bradenton brought it forward in an effort to make Bradenton more modern. Construction was completed in 1927, and since then, it has served as chamber of commerce headquarters, a radio station, a community center, and a number of restaurants. (City of Bradenton.)

IMAGES
of America

BRADENTON

Merab-Michal Favorite

ARCADIA
PUBLISHING

Copyright © 2013 by Merab-Michal Favorite
ISBN 978-0-7385-9078-3

Published by Arcadia Publishing
Charleston, South Carolina

Printed in the United States of America

Library of Congress Control Number: 2012942951

For all general information, please contact Arcadia Publishing:
Telephone 843-853-2070
Fax 843-853-0044
E-mail sales@arcadiapublishing.com
For customer service and orders:
Toll-Free 1-888-313-2665

Visit us on the Internet at www.arcadiapublishing.com

For my mom, Bonne' Sutton Favorite

CONTENTS

Acknowledgments 6

Introduction 7

1. The Pioneers 9

2. A Struggle in Survival 39

3. Business and Industry 69

4. Life and Times on the South Side 97

ACKNOWLEDGMENTS

This book would not be possible without the extensive resources available at the Eaton Collection in the Manatee County Library, the genealogy/historic collection at the Palmetto Carnegie Library, the assemblage of black history at the Family Heritage House Museum (FHHM) on the State College of Florida campus, the efficient employees of the Manatee County Historic Records Library, and the photograph collection of the State Library and Archives of Florida (SLAF). This book was drafted through their dusty photographs, remarkable genealogies, worn paper articles, digital records, and biographies.

Credit goes to the substantial archive of local interviews conducted by the Manatee County Historical Society (MCHS). Because of those oral accounts, Bradenton's story unfolded and sprang to life. Special thanks to Pam Gibson, the library reference director and a member of the historical society, who interrupted her busy schedule to help me solve historical dilemmas and gather records. Norma Dunwoody, a volunteer devoted to preserving the area's black history, helped me uncover Bradenton's African American flavor. Their patience and kindness inspires me.

Thanks to all the people who answered advertisements requesting family information—especially Lenore Stewart, Marianne Barneby, and Beverly Beall. They generously shared private treasures that enriched this work.

Finally, to all the writers, journalists, historians, and photographers who over Bradenton's years recorded the town's priceless legacy—thank you.

INTRODUCTION

The west coast of early Florida provided refuge and sustenance for two major tribes, the Calusa and the Timucua. The natives fished using nets woven of palm fiber and hunted game with arrows and spears. A chief Calusa priest held supreme authority over the southern territory, while the Timucua resided to the north. In both regions, the Manatee mineral springs held legendary status; their waters were considered curative and sacred. Beyond a ceremonial role, the springs were a trysting place for Indian maidens who met their lovers from the northern territory in the moonlight. To the natives throughout west-central Florida, the spring represented a font of hope, healing, and heartbreak.

Perhaps the natives drew on the spring's reputed supernatural properties to drive out Ponce de Leon when he arrived in 1521 to establish a settlement. De Loto likely drank from the waters of the mineral spring, never realizing that it was more valued by the natives than the mythological Fountain of Youth he long sought. But the waters held no protection against the tide of outsiders that followed de Leon. The invading armies interrupted the harmonic balance of life on the Manatee River in their searches for gold and other New World treasures. The soldiers required vast supplies to survive in the wild, and they grew desperate enough to destroy anything that stood in their way. Native arrows could penetrate several thicknesses of chain mail, but in the end, disease and superior weapons decimated the Calusa tribe.

Pafilo Narváez landed at the mouth of Tampa Bay in 1528 with 400 men and 80 horses. Although his journey was ultimately ill-fated, he slashed a brutal path through a normally peaceful land. Indian villages in his path became forging stations, and their people were subjected to torture and slavery.

Before the native tribes could recover from Narváez's onslaught, Hernando de Soto arrived on May 18, 1539, at Shaw's Point, another established Indian village. From there, he launched one of the world's greatest military expeditions, stretching more than 4,000 miles.

Spanish rule over Florida left a legacy of disease and death, but the explorers introduced free-range cattle, horses, and hogs imported from Europe. With the demise of the Calusa, Native Americans from the north migrated to Florida. In what is now Alachua County, Seminole Indians became the first cow hunters, domesticating herds of cattle and riding Spanish ponies. The outset of the Seminole Wars in the 1800s drove the Seminoles farther south, and present-day Manatee County became a sanctuary for displaced Seminoles and runaway slaves.

During the time it controlled Florida, Spain welcomed fugitive slaves, provided they would fight against the British to earn their freedom. After Florida fell under British rule (1763–1783), Seminole and Creek natives, as well as free blacks and escaped slaves, received British support to construct a fort on the Apalachicola River. Whites called it "Negro Fort" and considered it a threat. In July 1816, American naval forces destroyed it, killing all but a few of its inhabitants. Afterward, the remaining Seminoles and blacks formed a union and integrated. A group of black Seminoles eventually took refuge along the Manatee River. They, too, discovered the healing properties of the mineral spring and settled nearby, calling their village Angola.

For years, black Seminoles lived peacefully near the spring. The village of Angola melded with a neighboring fishing ranchero and evolved into an interracial community of Spanish-speaking residents who sold their seasonal catches in the Havana market. In 1834, a Baltimore-born captain named William Bunce, a former US customs agent, migrated to the Manatee River, becoming one of the first white men to enter the Gulf Coast fishing trade. Bunce acquired the fishing ranchero at Shaw's Point, embraced the native lifestyle, and employed the Spanish-speaking natives residing at the fish camp.

For a while, all was calm. Then the US government decided to enforce the Treaty of Payne's Landing, which called for the Seminoles to move to Arkansas Territory in self-exile. A few chiefs agreed to the treaty's terms, but the most powerful native leaders vehemently opposed the move.

War erupted after a group of whites sprang upon an Indian hunting party dressing a beef hide. They seized and whipped the natives, and one man was killed in the skirmish. The aftermath was the Second Seminole War, also known as the Seven-Year War (1835–1842).

As the war boiled on, accusations arose against Spanish fishermen for aiding the mix-raced Seminoles who lived among them. The government pressured Captain Bunce to expel his workers along with the rest of the Seminoles, but he resisted. Bunce pleaded with Gen. Wiley Thompson, the Indian agent for Florida, to spare them from deportation and the only life many of them had ever known.

It is unclear whether Bunce advised the Seminoles to hold their ground and refuse surrender or possibly even aided the Indians as they fought US soldiers. On December 28, 1835, Chief Micanopy and his warriors slaughtered Maj. Francis L. Dade and his troop of 112 soldiers as they marched from Fort Brooke to Fort King. Only three in Dade's command survived, including an African American named Luis Pacheco, whom Bunce had provided to the army as a guide. When the Indians withdrew, Pacheco went with them. The military believed that Pacheco had led the soldiers into the ambush.

If Bunce did collaborate with the Seminoles, he showed caution in dealing with them. In April 1836, reacting to a report that Seminoles were targeting fishing rancheros, he and his native family abandoned their settlement at Shaw's Point and relocated to Passage Key. Then, Bunce and his party cleared a grove of pines, using the wood to build shelters and a lookout tower. Later that month, Indians attacked and burned the Caldes Ranchero at Port Charlotte. Nearly 100 survivors escaped in pirogues to Passage Key.

With the swell in population, Bunce persuaded the US government to provide protection. In May, the warship *Grampus*, armed with eight cannons, anchored off the small island. Later, as hurricane season approached, Bunce moved his ranchero to the higher ground of Mullet Key, and the *Grampus* ensured a safe passage to the north end of the island.

In the summer, rumors circulated that Bunce told Seminole leaders to resist relocation to Arkansas Territory. In late 1837, a US military squadron torched Bunce's original ranchero at Shaw's Point. Only a concrete-and-shell tabby house stood afterward. The authorities, however, dared not touch Bunce, who was considered a man of influence and wisdom by the locals. In 1838, voters elected him to represent the Manatee region of Hillsborough County as a delegate to the constitutional convention, which was considering Florida statehood. Despite his popular standing, the US government still found Bunce a threat. Soldiers burned his ranchero at Mullet Key and deported the inhabitants, treating them as they did the Seminoles. Bunce died not long after the dissolution of his Indian family.

The close of the Second Seminole War set in motion the steps to attract settlers to the region; the Armed Occupation Act of 1842 provided any able-bodied man 21 years or older with 160 acres of land anywhere south of Ocala as long as he lived there for five years, cleared five acres of land, and built a house fit for human habitation.

Manatee County's first white settler, Josiah Gates, left Fort Brook in the fall of 1841 to stake his claim before the government officially released the lands and the rush began. Accompanied by his brother-in-law Miles Price, he sailed south on the *Margaret Ann*. As the ship glided down the coast, Gates happened upon an island where Spanish fishermen lived in a handful of palmetto shacks. The anglers were friendly, and one English-speaking Spaniard told Gates about an Indian village along the Manatee River. Gates went ashore, where he found a narrow path packed hard by Indian moccasins. The trail brought him to a circular pool about 12 feet in diameter: the sacred mineral spring of lore.

The land that once witnessed the destruction of native culture and later provided an asylum for those escaping slavery and persecution now held the promise of new beginnings. As Gates proudly walked his acreage, about 100 Seminoles remained in the territory, fugitives in their own country. Gates knew little of the history of the area, but he must have realized that others had settled here long before him when he found an abandoned five-acre vegetable garden. Indeed, for thousands of years, his new home had constituted the heart of the Florida Indian nation, but no longer.

8

One

THE PIONEERS

In 1842, the government released lands in the south Florida region, triggering interest in the area along the Manatee River. The government's assurance of reprieve from native attacks following the Second Seminole War prompted people from all walks of life to move south, hoping to carve out new lives by cultivating the lush undergrowth along the Manatee.

Any able-bodied man could apply for 160 acres of land as long as he was willing to live there for five years. While poverty-stricken families viewed the offer as a fortuitous break from sharecropping, others regarded it as an opportunity to gain back what they had lost. During the Money Panic of 1837 and the subsequent collapse of the Union Bank of Tallahassee, many plantations had gone bankrupt. Plantation owners were some of the first to arrive from northern Florida in hopes of regaining their lost fortunes. Hardy families arriving from the Carolinas, Georgia, and Virginia soon followed suit. They disembarked aboard barges, sailboats, and schooners. Some people even forged the treacherous terrain on horseback, others with wagons pulled by oxen, and a few barefoot.

Josiah Gates and a hardy band of pioneers labored to put down roots near the mineral spring. They built homes and started businesses, gradually creating the village of Manatee. To the west, another early settler, Dr. Joseph Braden, constructed a fortified encampment where employees of his sugar plantation could be safe with their families in case of Seminole raids. The settlement of Manatee remained the vital point along the river, but other communities began emerging along the coast.

Living in the region was far from paradise. Many suffered hardships, both physical and financial. Natural elements such as hurricanes and fires destroyed homesteads. A wave of Seminole attacks forced whole villages into fortified camps where they lived for months. Disease and sickness took its toll on young and old alike. But despite the difficulties, some residents managed a prosperous life from small-scale farming while other more ambitious businessmen amassed huge fortunes through slave labor and the export of wild cattle.

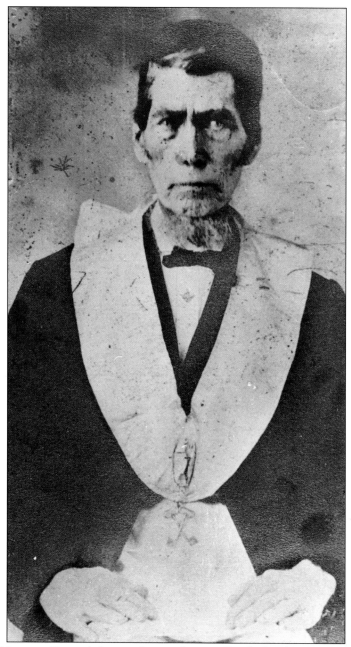

Josiah Gates, Manatee County's first settler, was born in South Carolina in 1802 and orphaned young in life. William Chaires, who later became one of the founders of Jacksonville, adopted him. As a young man, he traveled to Sylvania, Georgia, where he met and married Mary Magdalene Price on November 4, 1835. He operated a small inn for army officers at Fort Harlee in Alachua County during the Second Seminole War. After their first daughter, Sarah, was born in 1839, the family made their way to Fort Brooke. They traveled to the Manatee River in 1842 in a party led by surveyor Sam Reid. Gates became the founder and supporter of the village of Manatee. His children became doctors and preachers and leaders in the community. Josiah died in December 1924. (MCHS.)

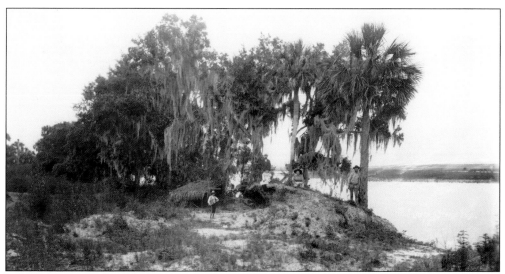

Palmetto huts were positioned on the beach near the mouth of the Manatee River in 1841. Seasonal Spanish fishermen Philippi, Manuel, and Perico constructed the palm-frond shelters. They dried and salted mullet and roe for trade in the Havana market. Philippi, who spoke English, joined the Josiah Gates party as its guide and told the party legends of a vanished Indian tribe. (SLAF.)

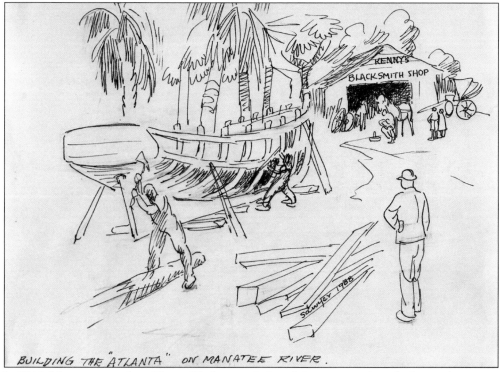

In 1846, Manatee proprietor Henry Clark commissioned the construction of a large schooner to import cargo for his store in Manatee. The town blacksmith, Thomas Kenny, built the vessel, called *Atlanta*. Philip Ayers Sawyer depicted the construction of the boat in this drawing. Hurricane swells overtook the overloaded ship on its maiden voyage, drowning the entire crew, including William Cabell Gamble, a prominent plantation owner, as it was returning from New York. (SLAF.)

The Manatee Mineral Spring was four feet deep with a white sand bottom and emptied into the Manatee River tributary known as Spring Creek. Native Americans and early settlers believed it had medicinal powers. In 1842, early pioneers settled near the spring, which gradually became the village of Manatee. In 1849, Dr. Franklin Branch purchased the property and began construction of a sanatorium, hoping to capitalize on the healing properties of the spring. During the Third Seminole War, Branch's outbuildings served as a fortress for residents, and the spring provided them with drinking water. In 1858, Branch sold the property to Capt. John Curry, who lived there for two decades. Dr. George Casper purchased the property in 1880 from Curry, with the stipulation that the Curry family could continue to utilize the spring. In 1904, the spring was included in the Manatee City Park and a gazebo was erected. (Both, SLAF.)

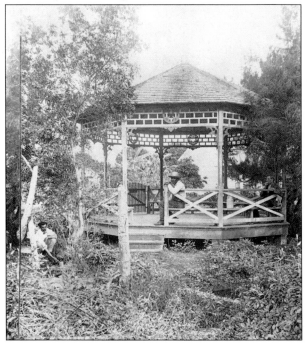

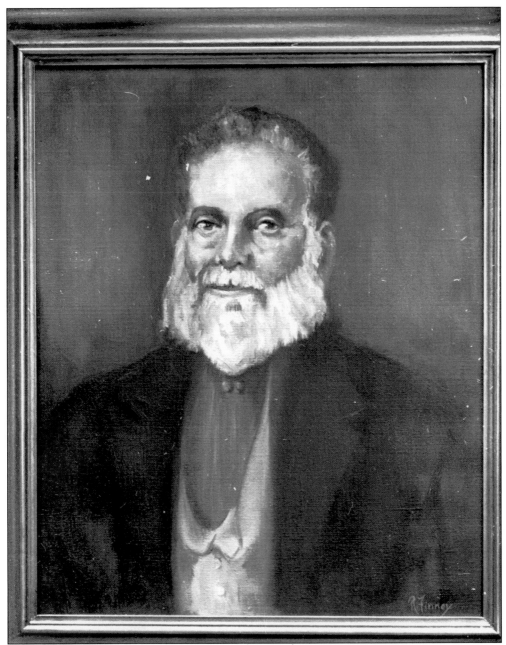

This portrait of Hamlin Valentine Snell by artist Ruth Finney Horney hangs in the capitol in Tallahassee. Snell was Manatee County's first representative to the Florida Legislature when he was elected Speaker of the House. As president of the Florida senate, he introduced the bill that created Manatee County in 1854. Being one of the early settlers of Manatee, Snell and his half-brother, William H. Whitaker, invested in property in Sarasota (then part of Manatee County), which they named Yellow Bluffs. Today, the site is located on Whitaker Bayou. They farmed the surrounding land and lived off seafood. During the Seminole Wars, their homestead was burned and their hired help, an Irishman named Owen Cunningham, was murdered, and only his heart was retrieved. Acting as militia lieutenant, Snell helped track the perpetrators. (MCHS.)

This portrait of "Mrs. Edmund Lee" is believed to be of Rev. Edmund Lee's first wife, Electa Arcott Lee (1807–1860). She came to Manatee with her husband in 1844 and held private classes in a room above her husband's store for $5 per term. A lean-to tin roof below the window created a slide for students exiting school. In 2000, Electa Lee Middle School was named for her. (MCHS.)

The US government granted a post office to Manatee village in the District of Hillsborough on January 15, 1850. Its first postmaster was Henry S. Clark. Ezekiel Glaizer was awarded a contract to deliver mail by boat between Manatee Village and Fort Brook; he eventually became the third postmaster. In the drawing below, Phillip Ayers Sawyer illustrated the first delivery of mail, with Captain Glazier at the helm. (SLAF.)

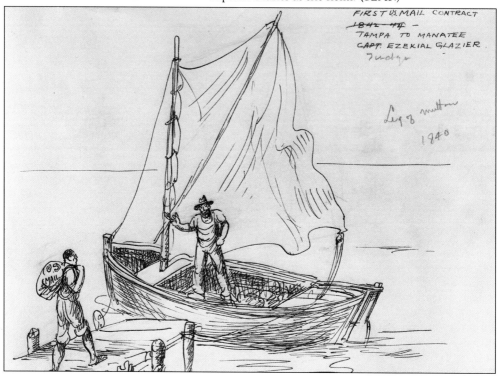

FIRST U.S. MAIL CONTRACT
1842 —
TAMPA TO MANATEE
CAPT. EZEKIAL GLAZIER.
Judge

Leg & mutton
1840

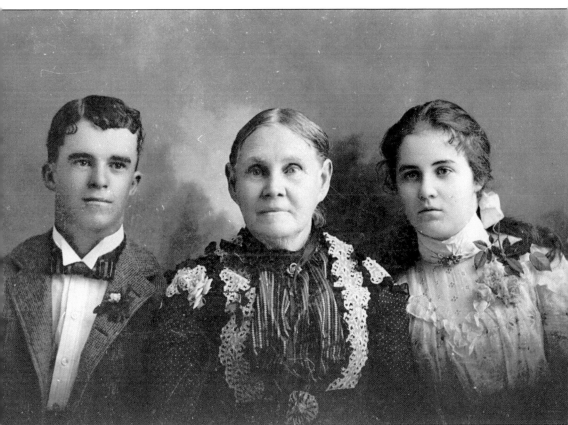

Mary Jane Wyatt Whitaker poses here with her grandchildren Harper Elliott Whitaker and Grace Spencer Whitaker. When Mary Jane arrived in the village of Manatee at age 11, she was crippled and confined to a wheelchair. Her aunt took her north to Jefferson, Indiana, where she was fitted with leg braces and learned to walk. In her northern environment, she was taught the standard abilities of a lady, but when she arrived back in Florida, she also absorbed the skills of the land. She was an excellent shot, rode horses, herded cattle, and had no trouble handling a boat alone. She met famous Seminole chief Holata Micco, also known as Billy Bowlegs, several times, rowing him across the river on one occasion; he reportedly admired her spirit. At 20, she married William Whitaker on June 26, 1851; it was the first wedding listed on the Manatee Methodist Episcopal Church register. In 20 years, she bore 11 children. She sewed her children booties of raccoon hide, stuffed mattresses with palm fronds, and marked her place in her Bible with a piece of seaweed. (MCHS.)

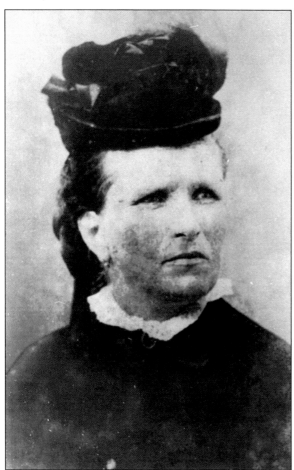

Amelia Curry Sawyer Wyatt was the fourth child of Capt. John Curry and Mary Ward Kemp. She was born on Green Turtle Cay in the Bahamas, where she married Samuel T. Sawyer and had one son, Theodore. The family came to Manatee in 1860. After Samuel's death at the Missionary Ridge prison camp during the Civil War, she married Rev. G. Hance Wyatt, with whom she had many children, in Manatee. (MCHS.)

Curry's Point, later called Point Pleasant, is pictured below from Manatee Light and Traction's power plant near Bradentown's Main Street (later Twelfth Street West). Recognizable in the foreground are the Sally Duckwall and Samuel Stanton homes. The Corwin Dock is in the upper right, and the small wooden building in the lower center is the original Bradentown post office. Ware's Creek stretches left in the upper portion of the image. (MCHS.)

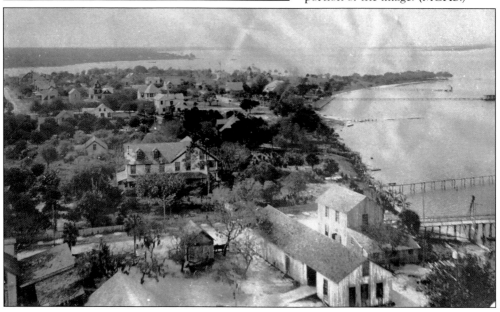

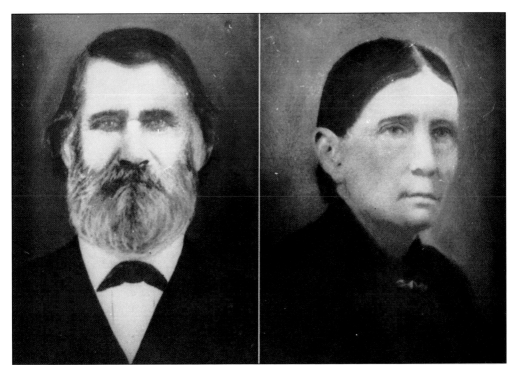

Maj. William Iredell Turner (above, left) was born in Virginia in 1812. He moved to Micanopy in 1839 and married Isabelle Higginbotham (above, right). He served in the Second Seminole War, where he suffered a wound in the neck that inhibited his service during the Civil War. Major Turner is considered the founder of Braidentown because by beginning commerce on Main Street he changed the course of development and he named the town after Fort Braden. He died in 1881. (MCHS.)

Susan Hough, the daughter of John Hough and Lucy Carter, was born in Manatee in 1871. She served in the Manatee County School System, where she was affectionately referred to as "Miss Sue." She married Capt. Ollie L. Stuart on September 24, 1893. She died in 1951 after a lifelong commitment to education. (MCHS.)

17

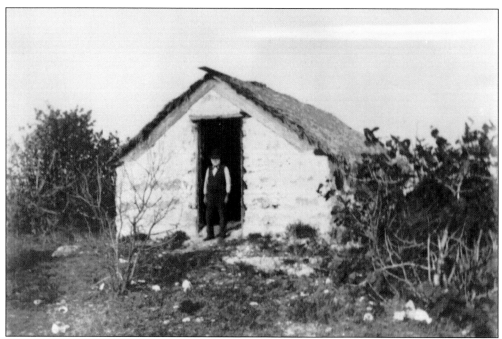

Above, Capt. Tole Fogarty stands in the doorway of a tabby house on Shaw's Point. The origins of the structure are unknown. Although William Shaw is credited with its construction, it is mentioned in texts predating his arrival in 1843. His family resided in the house until 1855. John Andress inhabited the house in 1859, later turning it into the area's first tavern, serving the crews that exported cattle. During the Civil War, the house served as an outpost for those on guard against Federal attack; a nearby Indian mound was the lookout. Below, a photographer stands atop the remains of the shell mound, most of which was hauled away for paving roads. The tabby house was also used as a post office at one point. In 1878, the building became a quarantine station. In its final years, treasure hunters dug up the floor. (Both, MCHS.)

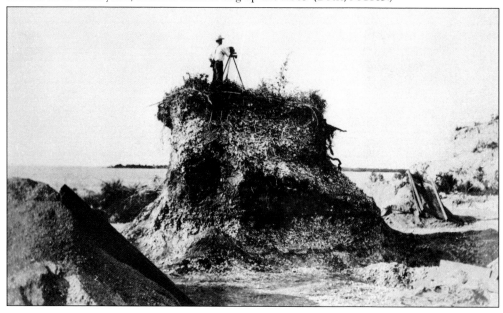

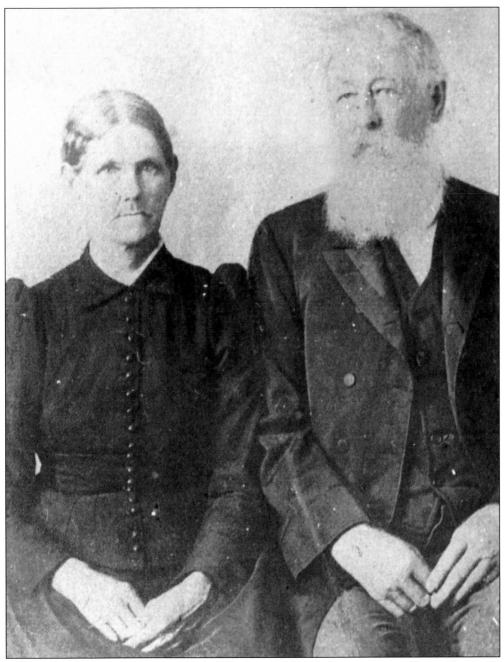

Palma Sola pioneers Martha Ann Andress Bishop and Asa Bishop are pictured here. The family originated at Bishop's Point in England before immigrating to North Carolina. Asa and Martha came to Manatee County with her father, John Andress, at the end of the Third Seminole War, in 1859. Andress chose to homestead near Shaw's Point on the Manatee River, where an old tabby house stood. Asa Bishop chose a plot just up the river, which became known as Bishop's Point. Not long after constructing a home for his family, Asa went to Tampa to join the Confederate forces. He fought through the major battles in Tennessee but survived and eventually returned home. He died at Bishop's Point on November 15, 1893. (MCHS.)

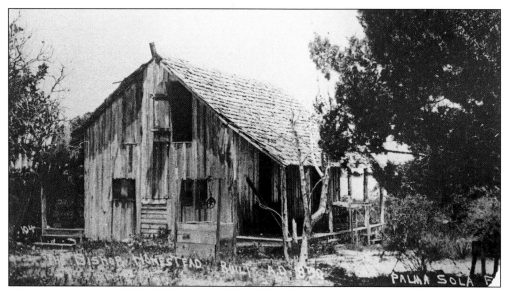

These are the ruins of the 1850 Asa Bishop home on Bishop's Point. A spring provided the household with water. In the time it took Bishop to build the house, two children were born. During the Civil War, Union soldiers came ashore to scout the property, and Bishop directed his family to hide in the woods, mimicking the call of the loon to alert them when it was safe to return. (MCHS.)

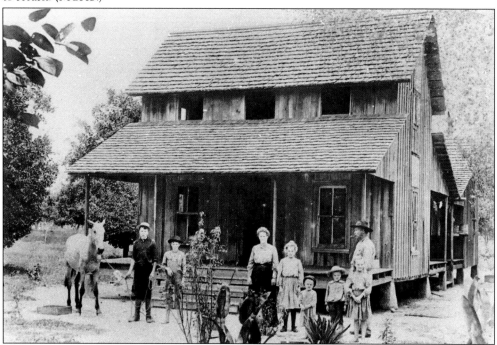

Edward D. Wilson is seen here with his children near Myakka City, where he grew oranges and potatoes. He applied for a homestead in 1903 and proved his claim in 1910. He served as the administrator of the estate of Nancy J. High, possibly his mother-in-law, in 1899. In 1902, he was reportedly called "the Miakka potato king" by locals. In 1907, he served as a trustee of the Maple Branch School. (MCHS.)

The Stanton siblings, William, Curtis, and Samuel Ward (seen above), grew up imitating their father, Samuel Stanton Sr., who was a successful marine architect and engineer. The family operated a shipyard in New York. After purchasing property in Bradenton, Stanton Sr. returned to New York to begin construction of a vessel that eventually transported his family to Manatee County and became a major means of passage for area residents. The *Manatee* launched in August 1884 after two years of construction. The family's voyage lasted 20 days. Samuel Jr. became a famous marine artist and author, and the sketch below is featured in his book *Steamships of America*. He was a passenger on the *Titanic* when it sank in 1912; his body was never found. (Both, MCHS.)

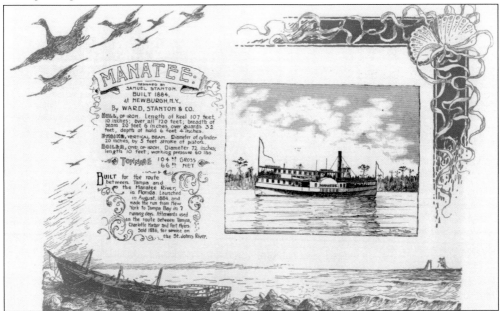

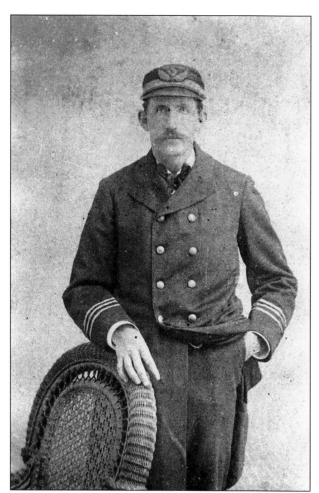

Capt. William "Bill" Stanton, born on April 10, 1861, disappeared from his home state of New York at age 15 and enlisted as a cabin boy aboard a vessel on a three-year voyage around the world. Stanton, the eldest son of Samuel Stanton Sr., ran the family sawmill after he moved to Manatee and provided wood for the very first telephone poles. He was the father of the Tampa Bay pilot Capt. Whit Stanton. (MCHS.)

Archie Rutledge (below) was one of the few black cattlemen in Manatee County. His father, Butch, worked as a butcher for Ferman Harrison, a white man who had opened a small butchering plant in 1917. Archie was helping his father skin cattle by the time he was 11 years old. At age 17, he was allowed to accompany the cow crews into the woods. He became an excellent horseman and a top cow hunter. (MCHS.)

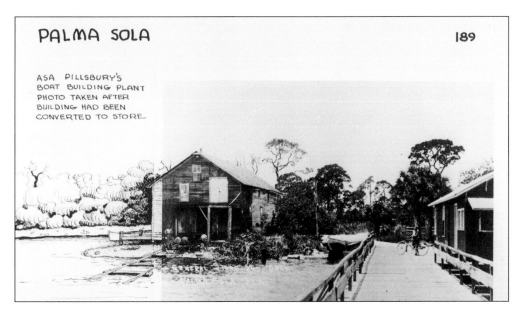

ASA PILLSBURY'S BOAT BUILDING PLANT PHOTO TAKEN AFTER BUILDING HAD BEEN CONVERTED TO STORE

Asa Pillsbury Jr. came to Manatee County with his father in 1885, settling at Palma Sola. He was especially interested in boat building. As a boy, he constructed model sailboats to race across the Manatee River, one of which is currently displayed at the South Florida Museum. He married Cora Earl and built a home on Passage Key, then established a bird sanctuary where he served as game warden. The key was destroyed by a hurricane in 1921. Asa is most noted for starting the Pillsbury Boat Works (above) in Palma Sola and building skipjacks, specialty boats for fishermen. Pillsbury's proudest possession was an Indian burial mound on his property (below). Archeologists excavated the remains of more than 147 natives from the site. Until his death in 1969, he lobbied for his mound to be included in De Soto National Memorial but was never successful. (Both, MCHS.)

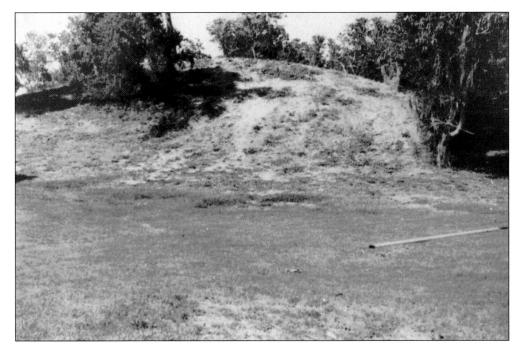

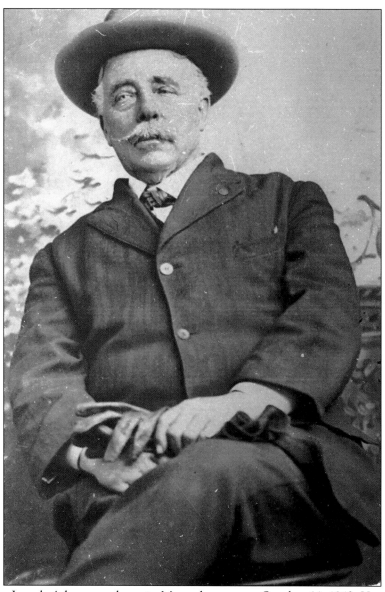

Maj. Alden Joseph Adams was born in Massachusetts on October 14, 1843. He served as a war correspondent for the *New York Herald* during the Franco-Prussian War and crossed the Atlantic Ocean 40 times during that period, becoming an accomplished linguist. He fell in love and married Adelaide Gilbert, an American, while in Rome. The extensive travel required for the job negatively affected his health; when he was asked to go to Africa in search of Dr. David Livingstone, he declined, instead recommending Morton Stanley, who famously inquired, "Dr. Livingstone I presume?" After retiring from correspondence, the Adamses purchased 400 acres on the Manatee River near the current site of Manatee Memorial Hospital. Adams was a store owner but also profited from his crop of 8,000 fruit trees; he exported the produce from a private wharf. After his first wife died, he married his young secretary, Maude Davis, after she rescued him from a fire. He served as mayor of Manatee, city councilman, and justice of the peace and donated land for a graveyard, which became Adams Cemetery, and a school. He died on June 17, 1915. (MCHS.)

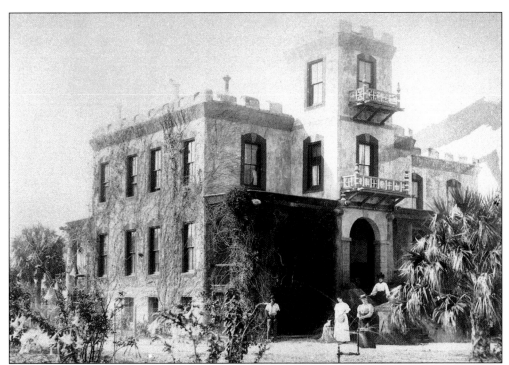

Adams Castle (above) was the 16-bedroom home built by Maj. Alden Adams and his wife, Adelaide. Construction took seven years to complete; Adams salvaged the interior woodwork from a sunken pirate ship, once almost drowning in the process. He imported exotic plants and released nonnative species, including monkeys and parrots, into the landscaping. John Moody purchased the castle in 1924 with the intention of remodeling it, but the project was never completed, and it was torn down. (MCHS.)

At right, Major Adams is seated between his two daughters from his second marriage, Tekla Maude (left), born on November 28, 1898, and Irma Adelaide, born on September 6, 1900. Their mother, Maude Davis, died from scarlet fever in 1902, and the girls were raised by a live-in aunt. Tekla was fond of wildly galloping into town on her horse, which resulted in her father receiving a citation from the town sheriff. (MCHS.)

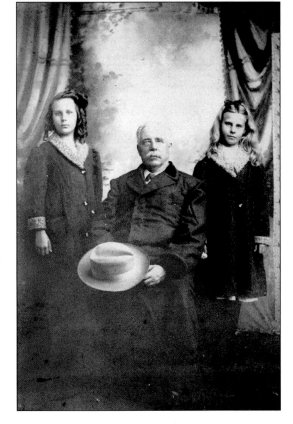

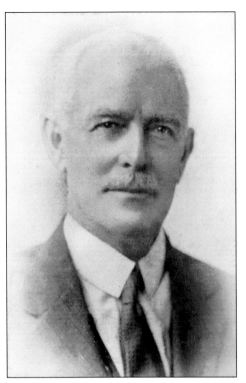

Dr. John Barnard Leffingwell (left) was a practicing physician and owned Braidentown's first drugstore. He ordered two "bootleg" telephones from Ohio, hoping they would make his business more efficient. They were installed by John's hired hand, Alec Richardson, who was the first African American associated with telephone history on Florida's west coast. Under Richardson's instruction, Leffingwell's teenage son, Jack B. Leffingwell, rigged the first telephone wire. Phones were installed in 10 households, and the switchboard was located in the Reed and Stuart general merchandise store. At the age of 14, young Jack spent $800 given to him by his uncle to purchase a citrus grove and extend the telephone wire to Tampa. Instead of a telephone line, he succeeded in bringing the community its first telegraph line. Below, Jack B. Leffingwell and an unidentified woman sit in a 1901 Oldsmobile. (Both, MCHS.)

Olive Hitchings was Braidentown's first official telephone operator. Lines were run to Oneco, Manatee, Sarasota, and Palmetto. A 50-line switchboard was set up in the Warren Opera House, but phone service was only available within the county; there was no outside communication. (MCHS.)

In 1882, widower Andrew Kitt Gowanlock (below, right) moved to Anna Maria to solve his health issues. His ailments were cured with the combination of saltwater, sun, and exercise that he received from his frequent boat trips to Braidentown. Utilizing the tides made the trips easier. He married Elizabeth P. Nichols on June 16, 1883. At age 102, he departed for New York to see his daughter, and he died after reaching his destination. (MCHS.)

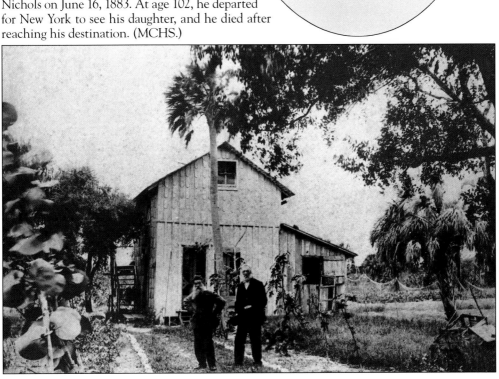

J.J. Scholtz started Braidentown's first photography studio opposite Courthouse Square on Tenth Street West. He worked with the carbon-photograph process and made beautiful tropical and marine views for tourists to purchase as souvenirs for loved ones. This photograph was taken in 1905. (MCHS.)

Charles Robert Zipperer and Laura Lee Wisenbaker Zipperer (below) moved to Braidentown from Georgia just before 1900 at the request of their cousins, Hubbard Gates and his wife, Lilla Corbett Gates. Lilla's mother was a cousin of Charles Robert Zipperer on her mother's side. Zipperer Road is named in the couple's honor. The young boy in the photograph, Adril Floyd Zipperer, later became the groundskeeper for John Ringling's estate in Sarasota. (Sherri Buete.)

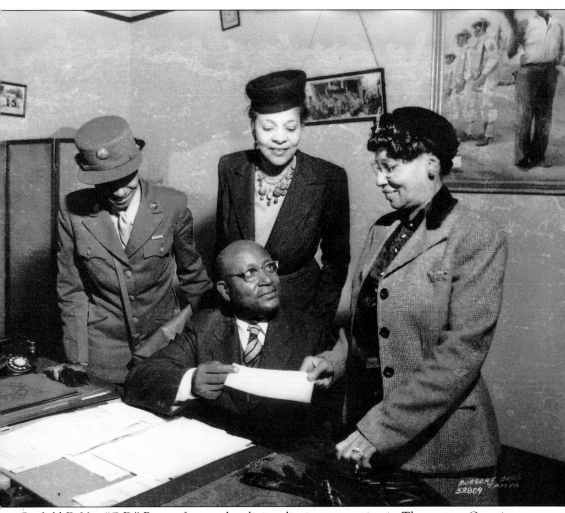

Garfield DeVoe "G.D." Rogers first made a living dipping turpentine in Thomaston, Georgia, but dreamed of greater things. In 1905, he walked along railroad tracks from his hometown to Braidentown, selling railroad ties to buy food and passage along the way. He first opened a dry cleaning and tailoring business on Ninth Street in Manatee, crafting suits for $13.50; it was the first of his many profitable businesses. He turned Central Life Insurance Company, which sold policies to black people during segregation, into a million-dollar company after taking it over in 1933. Above, Rogers accepts a life insurance check. He also purchased the land and the building for Lincoln Academy, where he served as principal, in 1930. With the help of Thurgood Marshall, the chief counsel for the National Association for the Advancement of Colored People (NAACP), he campaigned for equalization of salaries for black teachers in Manatee County in the 1940s. His daughter, Louise Rogers, became the first black member of the Manatee County School Board. When G.D. died in 1951, the funeral procession stretched over 50 miles. Several state officials and congressional representatives were in attendance; many of them stood outside Bradenton Methodist Church. (Hillsborough County Public Library Cooperative.)

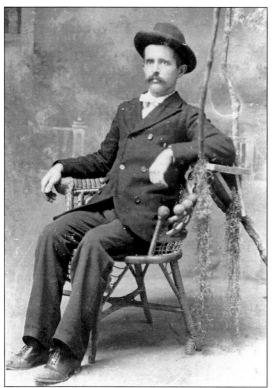

John Pettigrew's father brought him to Manatee in the late 1890s with hopes that the mineral spring would cure John's failing health. His health did eventually improve, and he married Mary Glee Davis. The couple moved to a home on Palma Sola Bay. Pettigrew erected a windmill that pumped water collected in a holding tank throughout the house, thus becoming the first local owner of indoor plumbing. (MCHS.)

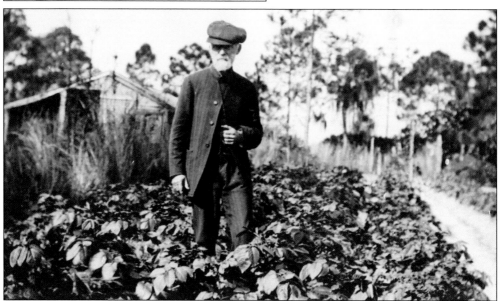

A.I. Root stands in his garden, which lay between his home and Ware's Creek. He was from Medina, Ohio, and was the founder of the A.I. Root Company, which manufactured beekeeper's equipment and supplies. By 1977, his company was the largest of its kind in the United States and was operated by Root's grandson, Alan Root, and A.I.'s great-grandsons, John and Brad Root. He built his winter residence in Bradenton in the early 1900s and wintered here until his death in Medina on April 19, 1923, after which his property was sold; his house was replaced during the 1925 Florida boom. (MCHS.)

Capt. William H. Vanderipe and his wife, Eliza Burts Vanderipe, owned a supply store in Braidentown. William, a Confederate veteran, was one of the leading cattle merchants in the area and had his own cattle-loading dock. He and three others established the Bank of Manatee with $16,000 in capital. Vanderipe, who was purportedly the best and most economically responsible Manatee county commissioner, died in 1901. (MCHS.)

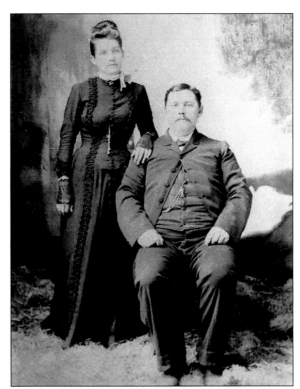

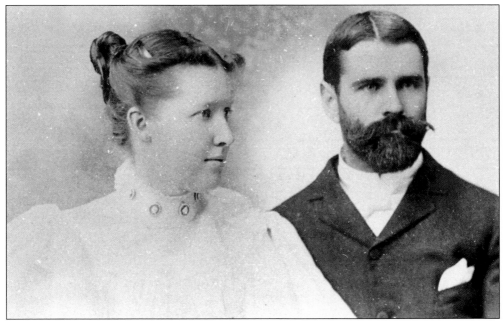

Egbert Norman Reasoner, born in 1869 in Illinois, married Sarah Burrows Anderson in 1895 and took over the Royal Palm Nursery after his brother Pliny died in 1888. The list of tropical fruits and plants offered by the nursery was extensive, with newspaper advertisements boasting more than 22 different plants. Reasoner died in February 1926 at only 56 years of age. The family-owned business is still in operation. (MCHS.)

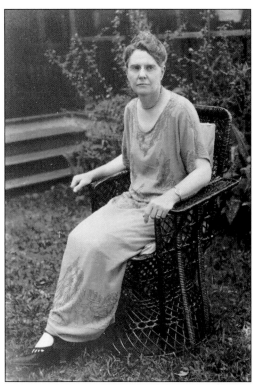

Julia (Reasoner) Fuller is seen here in front of her home at 1707 First Avenue West. She was the daughter of Egbert N. Reasoner. Throughout her lifetime, she kept scrapbooks chronicling events in the area. Her collection paved the way for others to capture Manatee County's early history. She also began the first library in Bradentown and served as the first librarian. In 1974, her home was sold to William A. and Bette M. Roseberry. (MCHS.)

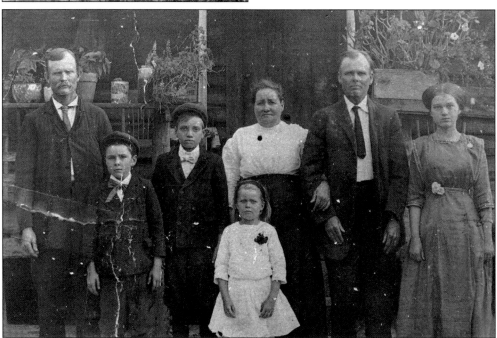

The David Rogers family poses in front of their home in the Albritton settlement in northeastern Manatee. The little girl in the white dress in front is Effie Rogers, and standing from left to right are Joe Rogers, "Young Earl" Singleton, unidentified, Mattie Davis Rogers, David Rogers, and Ella Rogers. (MCHS.)

Benjamin and Norma Dunwoody of Bradenton pose for a formal portrait in Miami on a 1939 trip to visit their mother. As an adult, Norma Dunwoody discovered the forgotten history of Lyles-Bryant School, the first African American school in Manatee County. To prove that the school existed, she spent two years researching telephone directories, microfilm catalogues, and minutes of official meetings. She currently volunteers at the Family Heritage House Museum. (FHHM.)

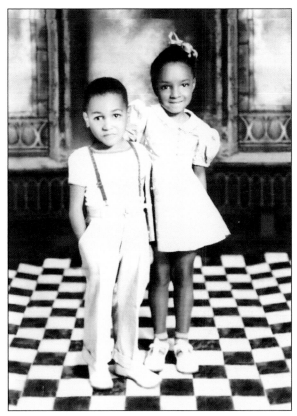

Le Chalet was the dream house of John Hodler, a retired cabinetmaker who crafted elaborate woodwork for Pullman railcars around 1880. Construction began in 1886 on Manatee Avenue West and Twenty-second Street, but it took Hodler 10 years to complete his masterpiece. Le Chalet was demolished for future development on May 5, 1984. In its last years, it was used for rental apartments, and the original floor plan was destroyed. (MCHS.)

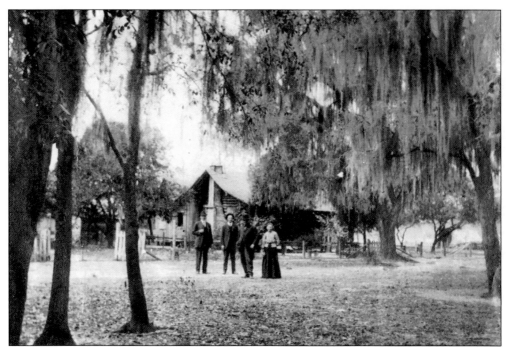

This log cabin was built in 1875 on the Myakka River and belonged to William Augustus Durrance and Dora E. Womack Durrance. Like many homes of that time, it was constructed with slash pine and had a rail fence around the perimeter of the property to keep wild animals out of the family vegetable garden. (MCHS.)

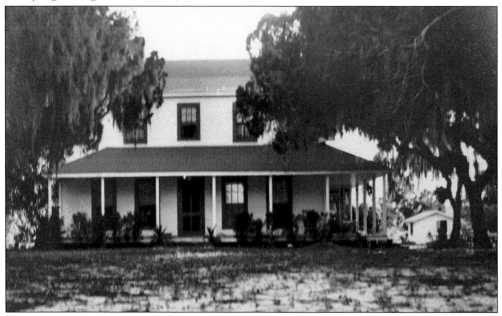

Sans Terre was built by Curtis Gilbert between the Manatee River and Warner's Bayou. Warburton Warner, at age 22, married Gilbert's daughter Helen in 1872. They lived with her father in this house. Warburton developed Palma Sola and advertised it as "The Youngest and Largest Town in Florida." The home was demolished in the late 1990s. (MCHS.)

The four Fogarty brothers—Jerry, William, Bartholmew, and John—were the founders of Fogartyville, a settlement at the end of what is now Twenty-sixth Street. Capt. John Fogarty first came upon the Manatee River Section while seeking shelter from a storm in 1865. He took the crew in a small craft to the village of Manatee and was impressed by the inventory of Rev. Edmund Lee's general store, so much so that he bought Lee's entire stock for $40. Captain Fogarty returned in 1866 and purchased land. His two brothers expanded on his homestead. The brothers quickly built the family boat works, which was the beginning of Fogartyville. In the ensuing years, they developed a thriving business building small boats. William H. Fogarty's home is below. (Both, MCHS.)

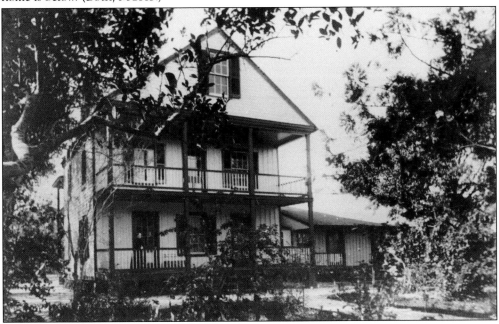

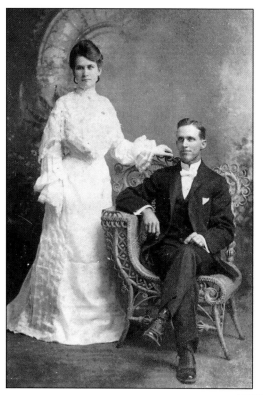

Charles Moore of Egmont Key married Roberta Lightfoot of Bradentown on May 26, 1904. Moore had moved to the island as a baby, and when he was 13, he was sent to school in Fogartyville. After attending Rollins College, Moore returned to Fogartyville and worked for Capt. Bat Fogarty, eventually becoming his partner. A daughter, Roberta, was born to the couple in 1910. (MCHS.)

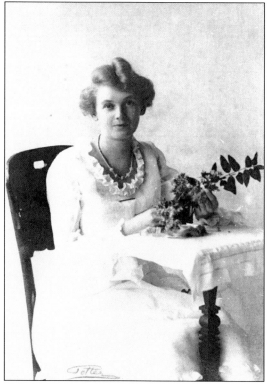

The women of the community were excited on September 9, 1920, when Bertha Curry (right) became the first woman to be certified to vote in Manatee County. She was registered by her father, W.V. Curry, who served as the supervisor of registration. (MCHS.)

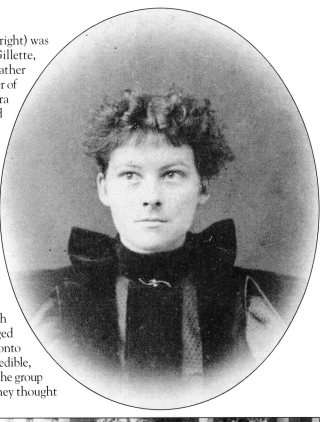

Nancy Mirah "Nannie" Richards (right) was born on December 20, 1875, in Gillette, a settlement named for her grandfather Daniel Gillett. She was the daughter of Daniel Richards and Nancy Elmira Gillett Richards and married county judge James Jones Stewart on June 26, 1875. The couple had four children: Zela, Jack, Glasgow, and Lilith, seen below from left to right outside the former Bahrt House on Riverview Boulevard West. Nannie's pride and joy was her motor launch, *Zela*. She was an excellent helmsman and could even repair an engine. She often took her children and guests out scalloping and camping. Once while camping on Anna Maria, Nannie had trouble catching enough fish to cook for dinner but managed to catch a shark, secretly pulling it onto the beach. Shark was considered inedible, but Nannie fried it up anyway, and the group bragged about the delicious pork they thought they were eating. (Both, MCHS.)

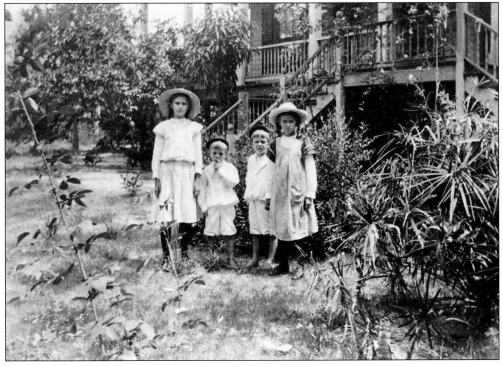

Zela Elizabeth Stewart, the daughter of "Nannie" Richards and James Jones Stewart, went to teach in the one-room schoolhouse on Snead Island in 1917. She moved to Washington, DC, in 1918, where she was employed by the War Risk Insurance Bureau during World War I. At the conclusion of the war, she took a job with the post office in Tampa. She eventually moved back to Fogartyville and married Thomas Fulton Crews. (MCHS.)

Florine Jones Abel (below) worked in education for 43 years, bridging the time from racially segregated schools to the modern educational era. In 1945, she became the first female African American principal in Manatee County. She served as superintendent of Negro education from 1959 to 1965 and then worked as an advisory specialist until her retirement 1971. In 1980, Abel Elementary was named in her honor. (MCHS.)

Two

A Struggle in Survival

In the early years of settlement, Bradenton's pioneers began to face a series of struggles—wars, disease, and natural disasters among them.

For a time, the settlers were on good terms with the Seminoles. Merchants in the village of Manatee traded with them regularly. In 1848, however, two attacks by Seminoles at nearby trading posts raised fears of a full-scale uprising. Seminole leaders blamed renegades within the tribe. Nonetheless, settlers and the military took preparations to build up defenses, and a series of skirmishes that followed led to deaths on both sides. The Third Seminole War (1855–1858) began after Army troops destroyed the prized vegetable crop belonging to Chief Billy Bowlegs.

Families abandoned their homes and congregated in Fort Branch and Fort Braden. The crowded conditions at the forts, plus shortages of food, encouraged disease. Whooping cough and measles broke out during the nine months of the siege. After several area homes were attacked, heads of households were obliged to form militias, leave their families, and do battle in the Everglades.

Just two years after the end of the Billy Bowlegs War, Florida became the third state to secede from the Union, and residents packed muskets in preparation for the Civil War. When Union ships guarded Tampa Bay, coastal captains became blockade runners to keep trade surviving as long as possible. It was a risky business, for if they were captured, their ships and cargo were confiscated and they were imprisoned. Many residents aided the rebels: a local watch was stationed at the mouth of the river, cow hunters drove stock north to feed the starving Confederate army, and women sewed uniforms. Because the blockade hurt commerce, the Manatee County Commission levied the first property taxes to purchase food for needy families.

Due to the area's remoteness, residents escaped the worst of the Reconstruction era. Cattle survived on the open range, and it was not long before trade with Cuba commenced. With Confederate money worthless, merchants were fortunate that the Cubans paid them with gold doubloons, a single one valued at $15.50 in US currency.

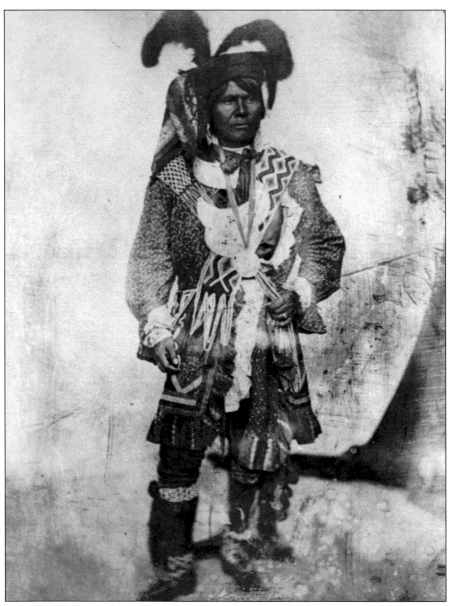

Seminole chief Billy Bowlegs, also known as Holata Micco, often made peaceful visits to the people of Manatee. Records indicate that Bowlegs was welcomed into the homes of the Gateses, the Wyatts, and others. In 1850, the federal government offered him $215,000 to take his tribe west. Bowlegs refused and ventured to Washington, DC, with hopes of resolving the issue. In 1855, troops destroyed Billy Bowlegs's garden, the cultivated land that fed his people. This act provoked the Third Seminole War, which lasted three years. During that time, Seminoles raided homesteads, burned bridges, and looted stores. The Seminoles eluded the Florida militias by traveling into the Everglades, where horses could not go. A female Seminole guide named Polly aided the US militia in its pursuit. In 1858, Bowlegs gave himself up, and he and his party of 123 Seminoles were taken to Egmont and imprisoned until they could be deported to Louisiana, where they would join others on the Trail of Tears. This photograph of Billy Bowlegs was taken in 1852 and is believed to be the oldest image of him. (MCHS.)

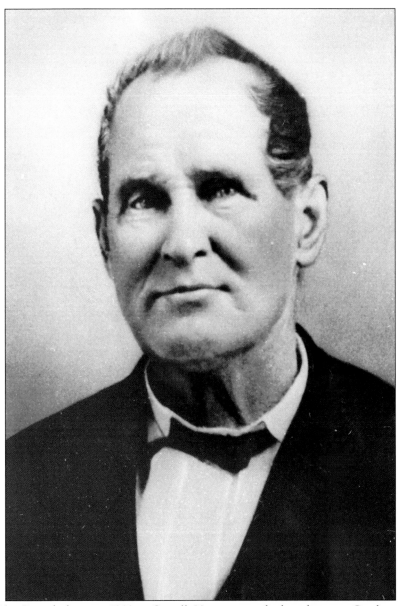

Dr. Franklin Branch, born in 1802 in Orwell, Vermont, studied medicine at Castleton Medical College and graduated in 1825. He and his second wife, Matilda Vashti Wilson, moved to Manatee in October 1846 and purchased the land that included the mineral spring. Branch planned to build a sanatorium and utilize the healing properties of the mineral spring to treat his patients. The buildings he constructed were instead fortified with sable palm trunks for protection against the Seminoles. Instead of patients, residents of Manatee occupied the structures of what became known as "Fort Branch" for nine months. Branch delivered three babies and treated a variety of ailments during that time. Following the death of his wife, he sold his landholding to Capt. John Curry of Key West. He also donated land west of Old Manatee Burying Ground, which became Manatee Village Historical Park, for a church and school. Branch and his family moved to Tampa to reestablish his medical practice. The Manatee River settlements were left without a physician during the Civil War. (MCHS.)

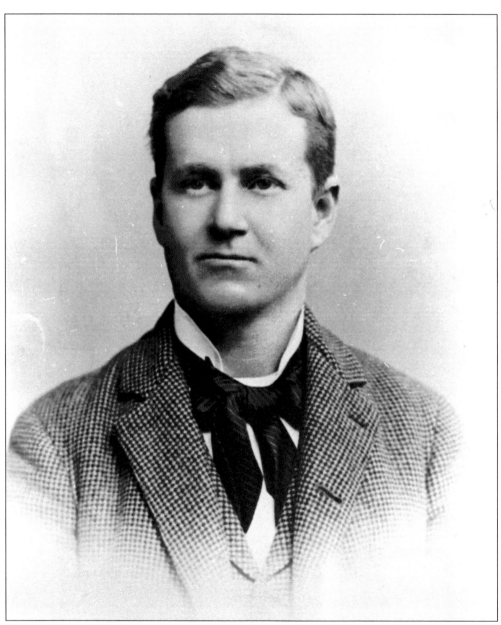

Furman Chairs Whitaker was the first native-born resident of Manatee County to become a doctor and practice in the area. He was born at Fort Branch on March 4, 1856, during the Third Seminole War. Seminoles burned the home of his parents. Furman injured his elbow as a boy; without the capability to perform physical labor, he was sent to Danville, Kentucky, to study. He returned in 1877. At the end of the Civil War, he witnessed preparations and plans for the escape of Judah P. Benjamin, the Confederate secretary of state, through Manatee County. He opened a store with his brother, Charles Clarence Whitaker, and in 1879, he married Nellie Louise Abbe. He established his medical practice first in Sarasota in 1896, then in Braidentown in 1898. From 1906 to 1909, Furman practiced general medicine, and then he went to New York City for his specialty diploma. Returning home in 1911, he was the first eye, ear, and nose specialist to practice in Manatee County and later in Tampa. He died in March 1945. (MCHS.)

Thlocklo Tustenuggee, or Tiger Tail, was a prominent Seminole leader. He always wore a strip of panther skin around his waist. He was well known by area settlers and was a regular guest of Robert Gamble. He chose death over being forcibly taken from Florida: as the Seminoles boarded their ship off Egmont Key, he swallowed powdered glass and died on the beach. This image comes from Nathaniel Orr's engraving in John T. Sprague's 1848 history of the Second Seminole War. (SLAF.)

Capt. John T. Lesley was born on May 12, 1835, in Madison County. He fought in the state militia during the Seminole Wars and in the US regular forces until 1858. Captain Lesley commanded Company K of the 4th Florida Infantry, the "Sunny South Guards," which was stationed at Shaw's Point. He was promoted to major in 1862 but resigned his commission in 1863 to recruit a "cowboy cavalry" company. He surrendered in Tampa at the war's end. (SLAF.)

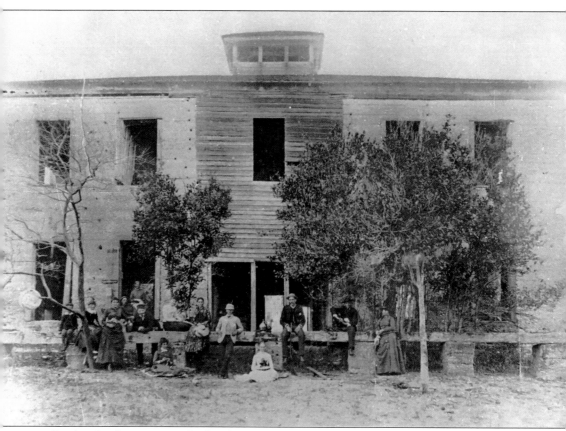

Braden Castle was originally the plantation home of Joseph and Virginia Braden. The two-story home featured walls two feet thick made of tabby, a type of concrete that combines lime, water, sand, and oyster shells. Nearby quarters housed 80 slaves. In March 1856, Seminoles unsuccessfully attacked Braden's home, but they kidnapped 14 slaves and looted the property before retreating. Residents of the village of Manatee tracked the Indians to Joshua Creek. They fired at the Seminoles for more than half an hour, killing three and wounding three. They then scalped two Seminoles, one of whom was still alive. The scalped Seminole was taken captive but died on the way back to Manatee. All the stolen property, including the slaves, was returned. The Bradens eventually abandoned the residence, and a fire destroyed it in 1903. The ruins became a popular picnic setting during the day, but locals avoided the area at night because the home was thought to be haunted. In the 1920s, it was discovered that the "ghost" was actually a large billy goat. (MCHS.)

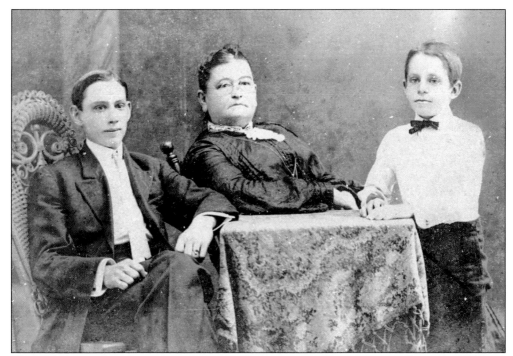

Eliza Burts Vanderipe poses with her two grandsons, Van Andrew Whitaker (left) and William H. Whitaker II. As a young woman, Eliza and her family narrowly escaped attacking Seminoles by sprinting for shelter in Braden Castle. An attacking Seminole was shot and lost an arm. (MCHS.)

Runaway slaves escaped farms and plantations using small boats to reach welcoming Union ships off the coast of Florida. In the Manatee Section, the escaped slaves were taken to Egmont Key and trained to serve in the Union army. (SLAF.)

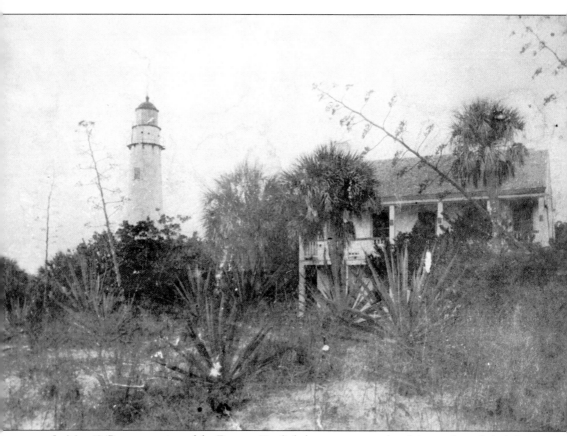

In May 1847, construction of the Egmont Key lighthouse was completed; it was the only lighthouse between St. Marks and Key West. The next year, it was damaged by a hurricane. The light keeper and his family survived by floating offshore in small boat tied to a cabbage palm. As soon as the storm concluded, the light keeper resigned. In 1848, a second lighthouse was designed to withstand any storm. The lantern burned whale oil. At the beginning of the Civil War, Confederate troops briefly occupied the island before Union naval forces captured it in 1861. They established a base for the Union gunboats that were blockading the area. Before the Confederates evacuated the island, they removed the lens and vital pieces of machinery from the lighthouse. Union troops never recovered the parts, and the lighthouse remained dark during the war. (MCHS.)

John William Curry, the son of pioneer Capt. John Curry, came with his father, his wife, Elizabeth, and the rest of the family from the Bahamas to Manatee in 1860. John W. Curry was appointed provision-master under Capt. John McKay of Tampa to keep the Confederate forces supplied with beef during the Civil War. He was a member of the Manatee Methodist Church, the oldest congregation south of Tampa. (MCHS.)

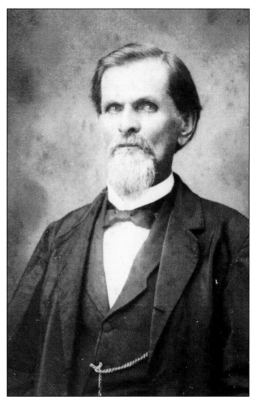

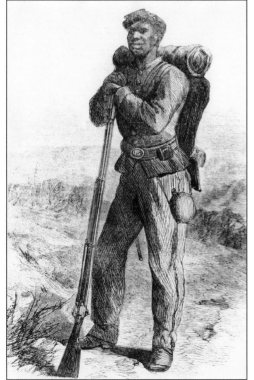

Approximately 133,000 black soldiers fought in the Civil War. The Union sent the 3rd US Colored Cavalry to halt the operation of John W. Curry, who was supplying beef to the Confederacy by driving herds north through the middle of the state. By the time the soldiers arrived at his ranch, all the cattle was already gone. (SLAF.)

47

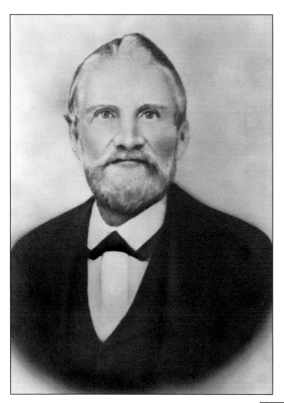

Capt. Fredrick Tresca, of France, was a great seaman. He remained neutral during the Seminole Wars and considered both white settlers and Indians friends. During the Civil War, he was a successful blockade runner. He helped Confederate secretary of state Judah P. Benjamin escape capture. Benjamin stayed at Tresca's home in Manatee, where members of the family knew him only as "Mr. Howard." Benjamin then traveled to the Bahamas and eventually Cuba aboard Tresca's yawl, the *Blonde*. (SLAF.)

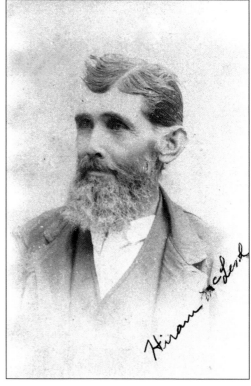

Hiram McLeod served in the Confederate army under Capt. John Lesley. At age 29, he returned from the war with a variety of injuries from the Battle of Murfreesboro. Despite his wounds, he aided the escape of Judah P. Benjamin. Aboard Tresca's sloop, the trio slipped out of Whittaker Bayou and sailed south along the coast, often evading Union ships by hiding in the mangroves. They eventually reached the Bahamas. (MCHS.)

A the close of the Civil War, Southern sympathizers harbored former Confederate secretary of state Judah P. Benjamin in the Gamble Mansion in Ellenton and then transported Benjamin to the home of Captain Tresca in Manatee while a plan was devised for his escape. Tresca's wife, Louise, sewed pleats in Benjamin's clothing to conceal coins. Benjamin hid in a wagon loaded with butchered beef to reach Sarasota, where he boarded the *Blonde* for the Bahamas. (MCHS.)

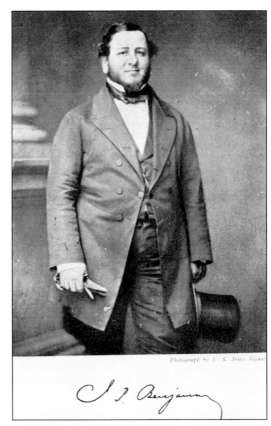

The Civil War left families destitute and patriarchs maimed from battle. The African American population had declined by over a third. In the 1880s, a small group of destitute former Confederate soldiers formed the Sarasota Democratic Vigilantes and began wreaking havoc, including the murder of black residents. Below, a group of African Americans hide after an attack. (SLAF.)

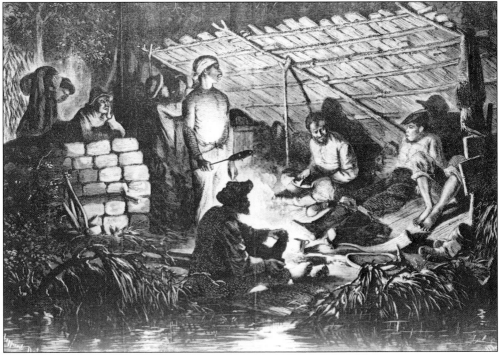

49

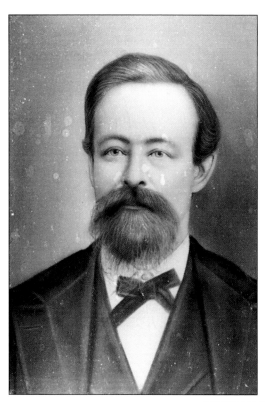

Dr. John Crews Pelot graduated from Jefferson Medical College in Philadelphia and married Mary Elizabeth Cooper in 1858. He moved his family to the village of Manatee in the fall of 1865 to escape the deplorable conditions following the Civil War. He was the first doctor after Dr. Branch and served the surrounding areas, including Bradenton, Parrish, and Palmetto. (MCHS.)

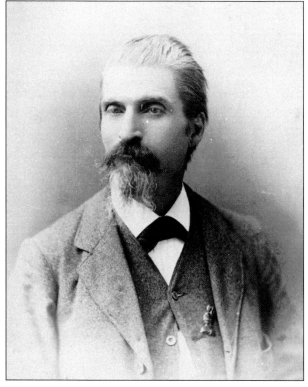

Residents along the Manatee River were outraged to hear that Sarasota's first postmaster, Charles E. Abbe (pictured), had been murdered by the Sarasota Vigilantes. Members of the group approached Abbe as he worked on his sloop. They shot him with a shotgun, slit his throat, dragged him down the beach, then placed his body in a yawl and sailed out three miles. His body was dumped overboard and never recovered. (MCHS.)

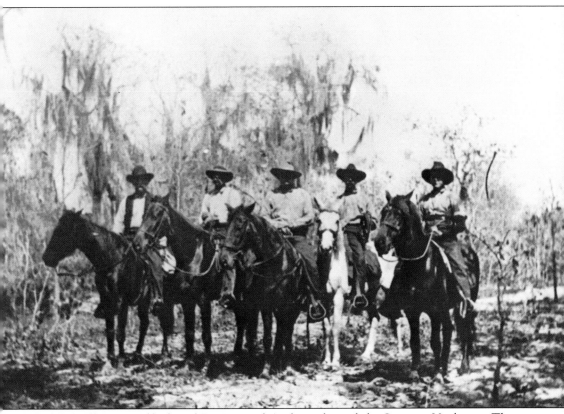

Alfred Bidwell, Jason Alford, and Dr. Leonard Andrews formed the Sarasota Vigilantes. The organization grew to approximately 20 members. Bidwell, a store owner, was a neighbor and competitor of Charles Abbe. The group formed after outside land companies, relying on information from locals, located squatters homesteading in the area and forced them to move. Abbe and Harrison "Tip" Riley were identified as informants and targeted by the group. Riley was fatally knifed and shot by Edmund C. Bacon. The group routinely harassed Abbe and his family. Charlotte Scofield Abbe reported waking up to the loud blast of a gunshot at close range and saw a shadowy figure just outside her window. Another time, she found an axe stuck in their table. Later Charles Abbe, too, was murdered. The alleged killers were escorted in irons by four mounted guards and taken to the jail at Pine Level to await trial. Bidwell tried to poison himself, but his suicide attempt was unsuccessful. (SLAF.)

Alexander "Sandy" Watson (left), sheriff of Manatee County from 1882 through 1896, formed a posse of two dozen men from the village of Manatee to investigate the murder of Charles Abbe. The search for the killers lasted eight days. Eight men were indicted. They were arrested and thrown in jail at Pine Level (below); the three who were considered the most dangerous were kept in a cage of iron bars. All eight were tried—three were sentenced to death, four were sentenced to life, and one was acquitted. A year after they were sentenced, Dr. Leonard Andrews and Edmund C. Bacon escaped, never to be heard from again. Alfred Bidwell's sentence was reduced to life in prison. (Both, MCHS.)

In September 1902, the county commission adopted plans for a new, modern jail. The bid was awarded to Pauley Corp., a jail-building contractor, at the price of $11,787.50. Residents were appalled by the price tag, and the court granted an injunction that was later lifted. The first legal hanging took place within the jail, located on Eighth Avenue Drive West, in 1905. On January 4, 1904, Ed Lamb, a mill hand at the Braden River Sawmill, murdered Dave Kennedy, a farmer, shooting him twice in the chest with a shotgun in front of several eyewitnesses. Afterward, Lamb and his family left town. The sheriff captured the fugitive but feared he would not be safe; he took Lamb to Tampa via train to await trial. Lamb was sentenced to death. On October 27, Lamb was hanged inside the jail in front of approximately 40 other prisoners. The drop fell at 12 minutes past noon, but the rope slipped and the prisoner was raised a second time and shot. (MCHS.)

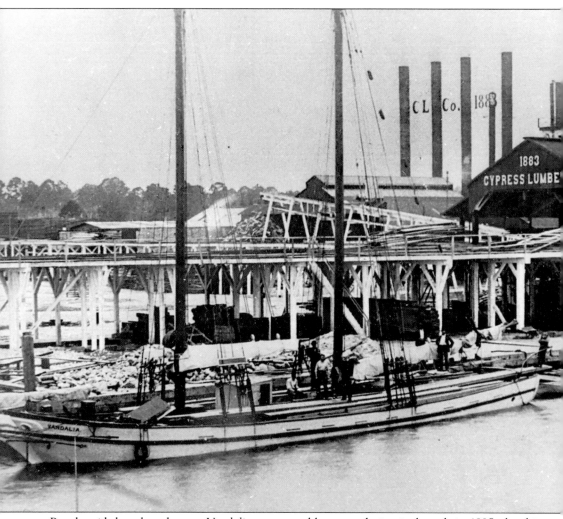

People said that the schooner *Vandalia* was cursed because, during its launch in 1895, the ship ran over and killed a workman. William "Will" Fogarty, son of William H. Fogarty and Eliza Atzeroth, supervised its construction at Fogartyville Boatworks. In 1906, Will sailed the *Vandalia* to Apalachicola to procure cargo for delivery to Key West. The ship is shown in Apalachicola near the Cypress Lumber Co. Upon returning from Key West, the ship ran into a squall causing hard winds and rough seas. For days, the residents of Fogartyville awaited the crew's return. Will's children recalled going to the dock to scan the horizon for his ship. Capt. John Miller, dispatched to search for the *Vandalia*, finally came upon it—capsized with no sign of survivors. Capt. J.J. Fogarty salvaged the ship and sold it. Years later, the ship caught fire and burned while moored to the Electric Dock at St. Petersburg. (MCHS.)

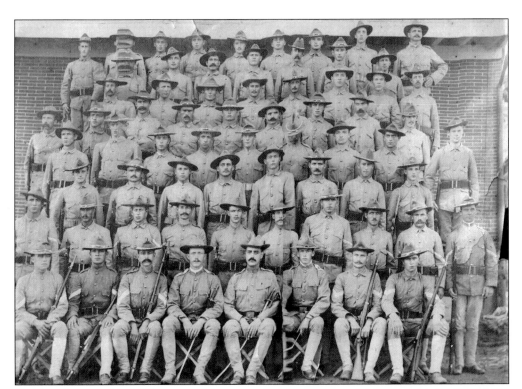

Tensions increased in 1898 as war with Spain appeared inevitable. Residents feared that the Spanish would invade Tampa Bay at any time. Fort Dade was erected on Egmont Key with temporary gun batteries and troop quarters. But the Spanish fleet never arrived. Young men of Bradenton enlisted in the military with hopes of defeating "Old Butcher," the name given to hated Spanish general Valeriano Weyler. However, most of the eager recruits never left the United States. Instead, they were sent north for training. The Manatee County boys (pictured above) returned home without experiencing any of the horrors of war. There was one exception; Matthew Hance Wyatt (right) joined Captain Burns's Tampa Rifles, or the "Fighting Six," which became part of the historic Fifth Army Corps and fought in the Battle of San Juan (during which Wyatt was erroneously reported killed in action). The battle lasted three days with a loss of over 200 Americans. (Both, MCHS.)

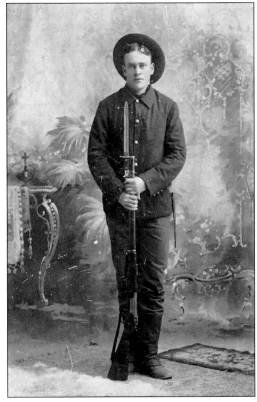

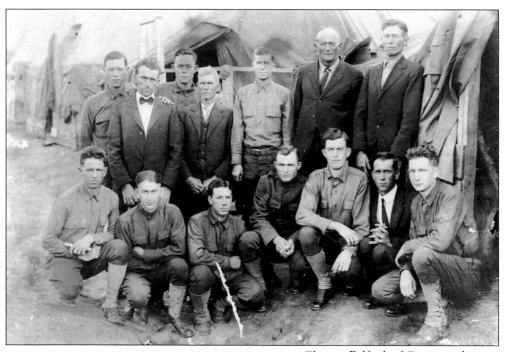

Clayton Fulford, of Cortez, is the fourth soldier from the left in the front row of the above photograph, taken at Fort Gordon in 1918 during World War I. Fort Gordon was home to three divisions: the 4th Infantry, the 26th Infantry, and the 10th Armored. Fulford later died of a gunshot wound sustained while cleaning his weapon. (MCHS.)

John A. Graham, of Braidentown, is seen at left in his World War I uniform. He sold railroad lands for the Southern States Land and Timber Company in 1902. That year, he began construction of an electric power plant in Bradenton and a trolley line from Fogartyville to Manatee. In 1918, Graham joined the Red Cross and worked at Camp Wheeler when it was hit by the first wave of the great influenza pandemic. (MCHS.)

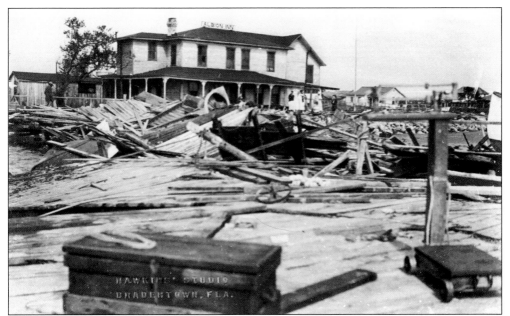

L.J.C. Bratton built the Albion Inn in 1894. Over the years, it served the winter visitors of Cortez, many of who returned season after season. Bessie and Joe Guthrie took the inn over in 1910 and operated it until the 1950s. The inn was the only waterfront building to survive the destruction of the 1921 hurricane. t was later used as a US Coast Guard station. (MCHS.)

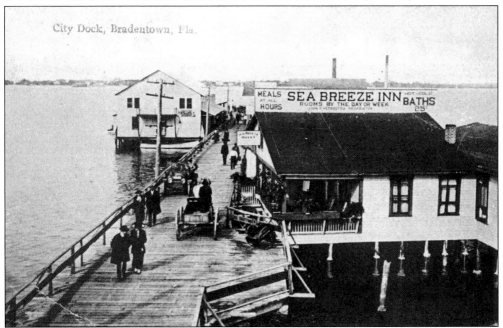

Tragedy struck the waterfront in December 1915, when the Seabreeze Inn, Hawker's Fish Market, and 150 feet of Corwin Dock burned during the night. Unable to get to shore, the guests remained trapped on the dock. The hotel's proprietor instructed guests trapped on the dock to jump overboard into the water. All were saved except J.H. Gray, a civil engineer for the US government, who burned to death in his hotel room. (MCHS.)

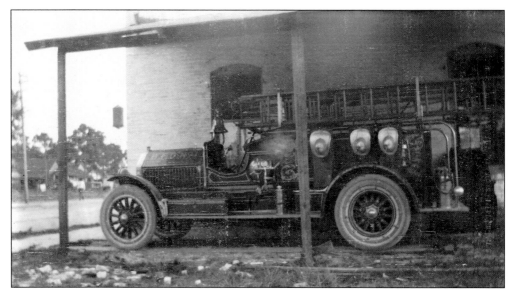

The largest fire in the city's history erupted on the night of August 22, 1912. The Manatee Carriage and Automobile Shop, the home of Mamie Green, and a variety of surrounding buildings were destroyed. The fire prompted Albert W. Harris to make firefighting his business. At first, the department functioned with a host of volunteers under Harris's direction. The city then purchased a pump engine with a drawn reel hose (above). In 1914, when Harris became chief, the department's equipment was valued at $550. By 1927, the fire department had two more trucks and a staff of four. The fire station was within city hall. Harold Silver and L.L. Hine are among the men pictured below. They proudly display their new equipment, valued at $52,000, for an article in the *Bradenton Herald*. The fire department moved out of the city hall building in 1970. (Both, MCHS.)

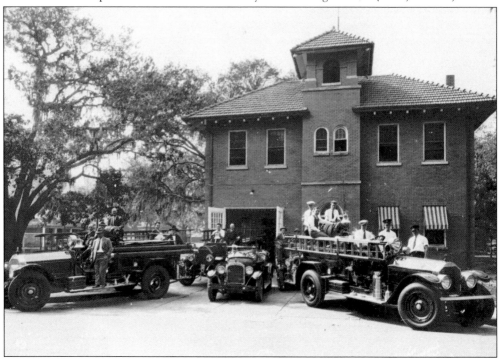

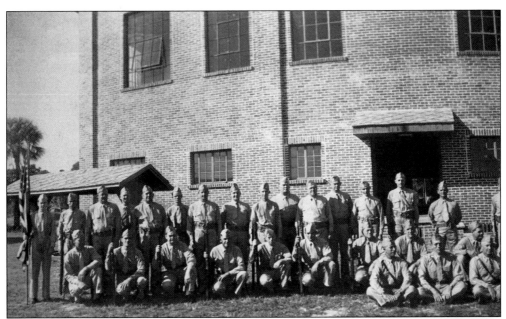

In 1939, Pres. Franklin D. Roosevelt provided funds to state National Guard units for equipment and arms as defense against Germany. Young men joined, never expecting to be shipped overseas; however, most of Florida's National Guard troops were called to service on November 25, 1940. Above, the Manatee County Home Guard stands outside its armory on Ninth Street West just before the United States joined World War II. (MCHS.)

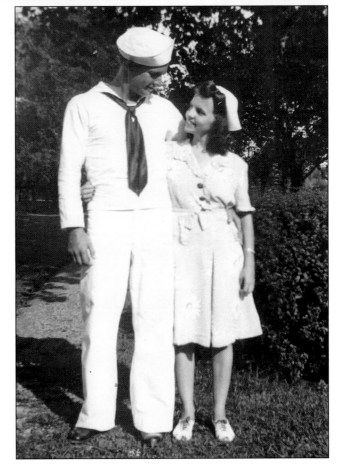

C.B. "Jack" Stewart did not want to let go of his new wife, Lenore, in this photograph. The two married shortly after they graduated in 1938, Lenore from Palmetto High School and Jack from Bradenton High School. Jack worked as an aerial photographer for the US Navy during World War II. He is pictured in his uniform. (MCHS.)

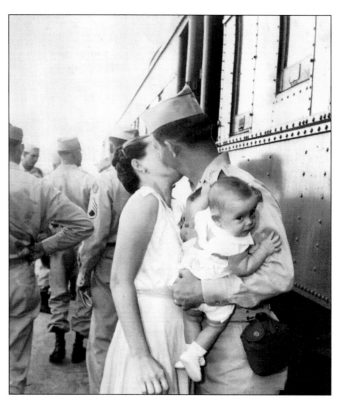

Donald S. Flowers kissed his wife and small child goodbye before boarding a train during World War II. Don served as a pilot in the European theater. He graduated from Palmetto High School in 1941 and entered aviation training. At the urging of Principal Boulware, the students of Palmetto High School raised more than $100,000 worth of war bonds under a US Treasury program to underwrite the cost of warplanes. A commemorative plate was installed in the cockpit of the plane to recognize the students' contribution, but unfortunately Don never flew it. Upon his return, Don owned and operated Foster's Drug Store on Main Street in Bradenton for more than 50 years. (Both, Don Flowers.)

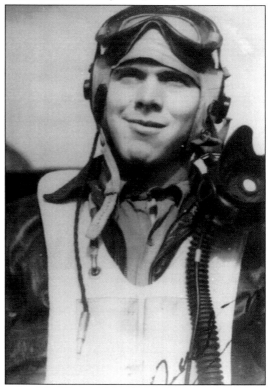

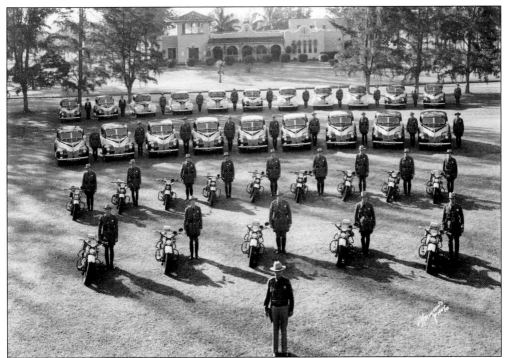

In 1939, the Florida Legislature created the state highway patrol. Mack Britt, the chief of the Manatee County patrol unit, was chosen from among 5,000 applicants to serve in the 31-man unit. The first academy was taught at the Bradenton Municipal Pier (now Pier 22). Troopers were housed at the Manavista Hotel. They trained at the site of present-day city hall. Mack remained with the highway patrol until 1955. (MCHS.)

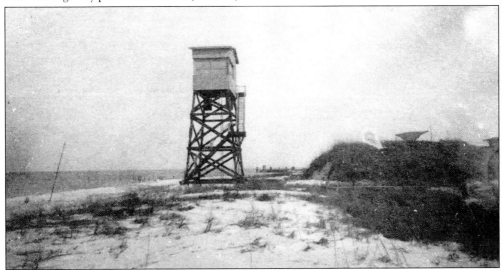

The attack on Pearl Harbor on the morning of December 7, 1941, shocked residents of Manatee County. Domestic support for isolationism was replaced by patriotism, and observation towers and blackout curtains immediately went up all over the county. From 1941 to 1943, several lookouts like the one shown here were constructed and manned around the clock by volunteers trained to listen for German aircraft and spot U-boats entering Tampa Bay. (MCHS.)

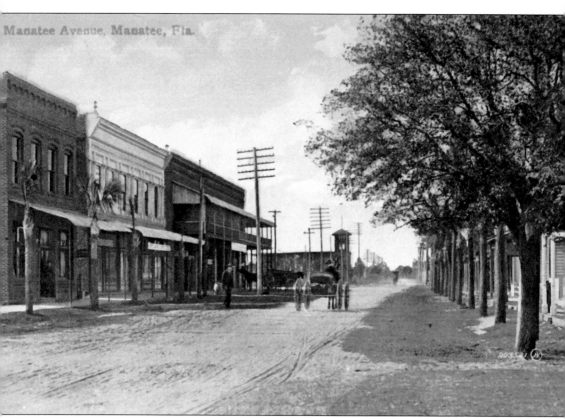

The Village of Manatee was incorporated in 1888, with Josiah Gates serving as the first mayor. In June 1903, the Florida Legislature passed a bill that doubled the town's area. The Florida boom of the 1920s spurred growth in Manatee, but when the stock market crashed in 1929, the town suffered financially. Worsening economic conditions forced the city to either declare bankruptcy or merge with Bradenton. Despite fierce opposition, the merger passed, going into effect on January 1, 1944. The Manatee Post Office immediately became Manatee Station. Longtime residents wore black bands in mourning, and soldiers returned from war to find their city gone in name. Today, Manatee is known as East Bradenton. (MCHS.)

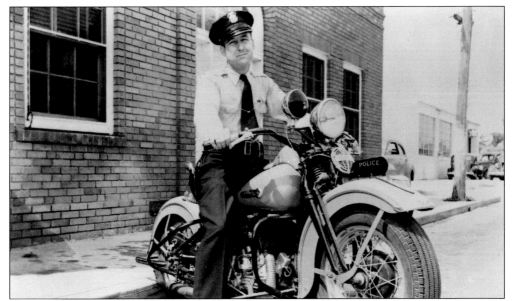

This photograph was taken in 1944, shortly after Clyde Gill joined the Bradenton Police Department. Until the 1960s, there were only six officers on the police force. It was not uncommon for them to work a 12-hour shift without receiving a single call. The force operated under a policy that gave each officer $25 for an arrest, no matter the crime. Gill served as police chief from 1971 to 1976. (MCHS.)

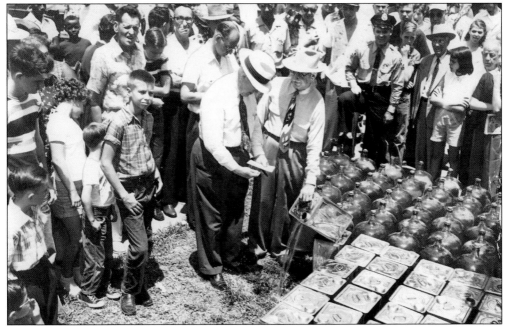

A crowd gathers in 1958 around Courthouse Square in Bradenton to witness Manatee County sheriff Roy Baden empty 535 gallons of moonshine he and his squad confiscated on a raid the night before. Lloyd Hicks, the clerk of the court, documents the event. Baden would often make a spectacle of his busts, especially during election years, but the homemade booze was purportedly his own—he allegedly had stills all over the county. (Personal collection.)

In January 1859, Ezekiel Glazier won the $1,000 construction bid for a county courthouse, despite another more elaborate two-story building option. This led to a dispute between Glazier and Sheriff James D. Green, with several letters printed in the Tampa newspaper by each man accusing the other of being self-serving. When Pine Level became the county seat, the courthouse was converted to a church and then a residence. In 1975, it was moved to Manatee Historical Village, seen here. (MCHS.)

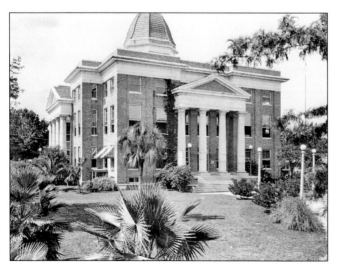

In 1888, a wooden courthouse was erected on the southwest corner of Main Street and Manatee Avenue. In 1912, the brick courthouse, which still stands today, took its place. The wooden structure was moved to a lot purchased by G.D. Rogers, where it became the segregated Lincoln Academy, serving black students in grades one through eight. Grades nine through 12 were added in 1931. The brick Manatee County Courthouse (left) featured columns and a cupola. (MCHS.)

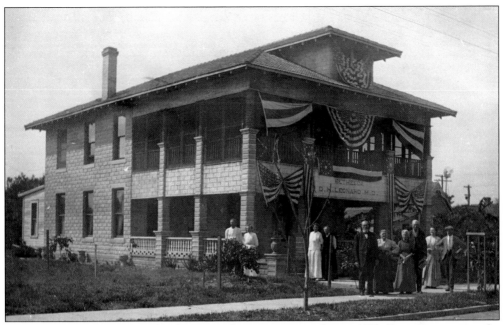

People stand outside the Bethesda Hospital on its opening day in 1910. For a time, it was the only hospital south of Tampa. It was run by Dr. Charles William Larrabee and his wife, Dovie Mae Collins Larrabee, a licensed nurse, benefitting and caring for all the people in the Manatee Section area. The Larrabees came to Bradenton in 1921, took over the 18-bed hospital on Ninth Avenue West, and converted it into the Larrabee Hospital. In 1925, the name was changed to Bradenton General Hospital. Over the years, it grew to a capacity of 30 beds with eight additional baby bassinets. The first operation performed there was in December 1920, and the last was in 1957. The hospital also provided the first real ambulance service beginning in 1924 (below). (Both, MCHS.)

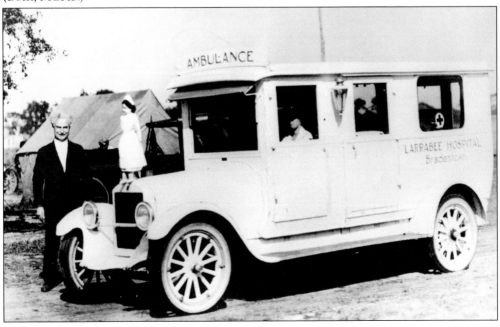

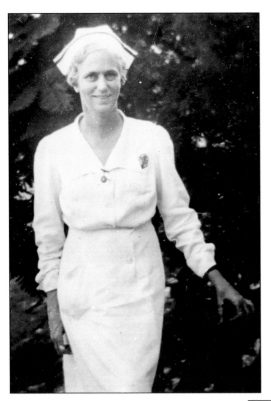

Dovie Mae Collins Larrabee, the wife of Dr. Charles William Larrabee, ran Bradenton General Hospital as the undisputed boss. She was a frugal and astute businesswoman and earned her RN degree at Louisville City Hospital's nursing school. Dr. Larrabee died on April 13, 1957, and Mrs. Larrabee closed the hospital a month later. Manatee Memorial Hospital was built and running by then. Mrs. Larrabee died on September 18, 1964. (MCHS.)

Dr. William Daniel Sugg (1897–1981) was a prominent surgeon and civic leader in Manatee County. For a number of years, he was the only surgeon south of Tampa on Florida's west coast. Between 1930 and 1937, he performed the vast majority of the surgeries at the Larrabee Hospital—more than 6,000. He owned most of what became Holmes Beach on Anna Maria Island as well as a substantial portion of Shaw's Point. (MCHS.)

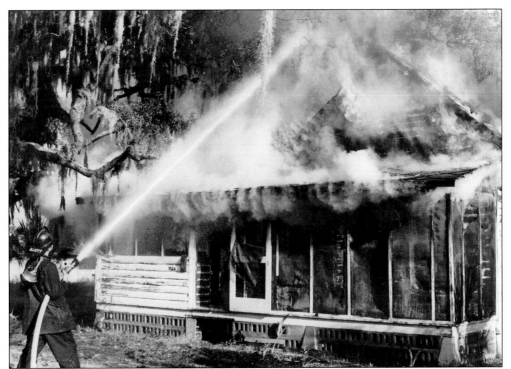

While this fire looks out of control, it was really just practice for three new firemen in 1966. Elizabeth Strickland, the wife of city councilman W.D. Strickland, owned the frame house. The fire, at 1326 Second Avenue West, attracted several dozen spectators. (Personal collection.)

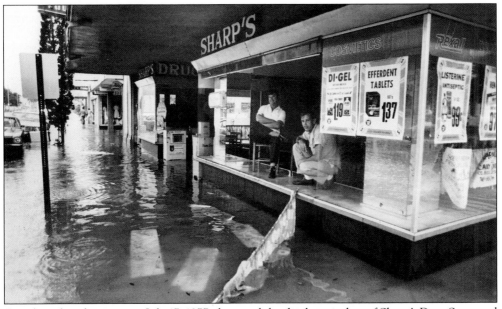

A violent thunderstorm on July 17, 1977, shattered the display window of Sharp's Drug Store and flooded Manatee Avenue. Damage to the city was estimated at $500,000. The hardest-hit section of the county was 44 Quarters, a section of homes housing mostly black families east of US 301 at Third Street East and Thirteenth Avenue. (Personal collection.)

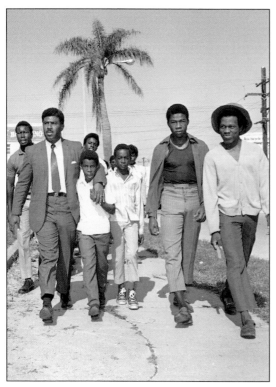

In March 1970, Manatee County was forced to comply with federal mandates regarding desegregation of schools. On April 6, 1970, Gov. Claude Kirk suspended Superintendent Jack Davidson and assumed control of the school administration building in an effort to halt the busing of African American students and teachers to primarily white schools. Dozens gathered around the school board administration building in protest. Kirk returned to Tallahassee, leaving his aides to deal with the federal marshals who arrived on the scene to arrest Kirk. The marshals refrained from busting in the door of the administration building when confronted by Sheriff Richard Weitzenfold and five deputies. People feared conflict, but the marshals prevailed and arrested the sheriff and his deputies for trying to uphold Kirk's order. No official charges were filed against Kirk, and by the end of the week, plans to begin busing students commenced. (Both, MCHS.)

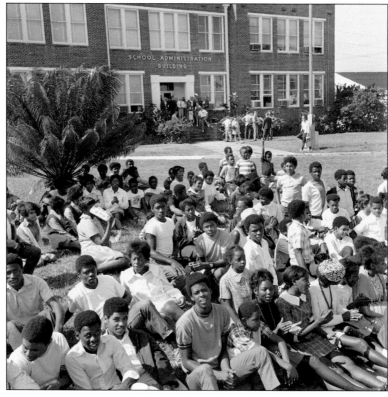

Three

BUSINESS AND INDUSTRY

Begun by the early native dwellers, fishing was Bradenton's first industry. The natives made nets woven of palm fiber and silk grass. Much later, during the Cuban trade period, Spanish-style nets constructed of cotton twine replaced the original material. After the Civil War, a wave of commercial fishermen settled on Florida's southern coast and established the fishing enterprise that continues today.

Early pioneers did a little bit of everything—fishing, farming, and raising and selling cattle. Capt. James McKay, an entrepreneur from Tampa, is credited with starting trade with Cuba in the late 1850s, shipping up to 400 cows a month until the Union blockade during the Civil War thwarted exports.

The history of organized agriculture in the area now known as Bradenton begins with sugar cane, which then led to celery crops, followed by truck vegetables, fruit, citrus, and tomatoes. After the area opened for settlement in 1842, the mild climate and rich soil attracted people of sufficient means to engage in large-scale cultivation.

At first, produce grown for market had to be shipped to Cedar Key. When Fort Braden eventually evolved into a town, Maj. William Iredell Turner proposed naming the community after Dr. Braden, but an error in the application by a city official resulted in it being named "Braidentown." Turner, considered the city's founder, envisioned a thoroughfare with access to a wharf on the Manatee River. His plotting of lots along Main Street spurred business development and produced a conduit for commerce and trade.

The *I* was not dropped from Braidentown until 1903. The W remained until the Florida boom era, when it was changed at the suggestion of developers who wanted the city to sound more progressive. The Great Depression in the 1930s hit the community hard. Manatee was forced to merge with Bradenton or face bankruptcy. Bradenton as it is known today was formed in 1944 with the merger of the two towns.

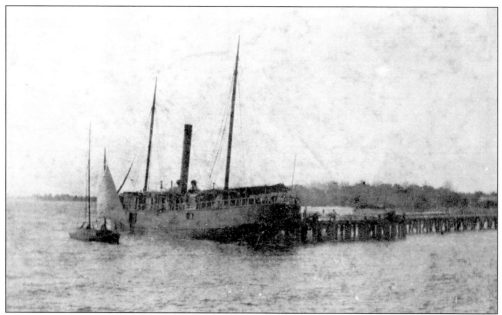

The export of cattle was a major industry in Manatee County. The original Florida crackers were hunters who used whips to round up free-range cows left over from the Spanish explorers of the 1500s. The horsemen branded them and then drove them to one of four loading docks on the Manatee River, the most prevalent being Shaw's Point. They were shipped to Cuba. The *Lizzy Henderson* (above) frequented the Manatee River. At one point, there were 1,036 recorded cow brands in Manatee County. Two epidemics, the fever tick in 1917 and the screwworm in the 1930s, completely depleted the native piney-wood cattle. Although Florida continues to be one of the leading beef producers in the nation, the original crackers became extinct with the demise of the piney-wood cattle and the disappearance of Florida's free range. Below, wild cattle congregate on the shore. (Both, SLAF.)

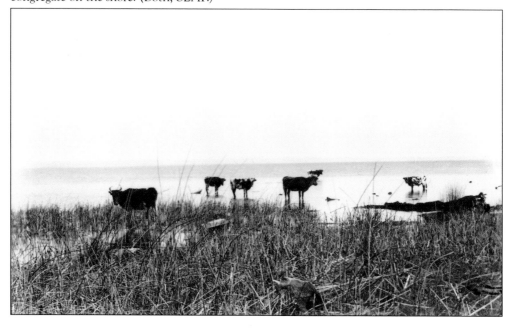

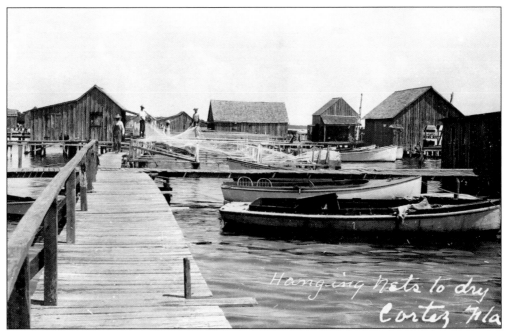

Commercial fishing was a vast industry in the area. Some of Cortez's early fish houses began as net camps, or a group of stilt houses that provided a place for commercial fishermen to rest. They were connected via walkways with racks built for drying their nets, which were hand-sewn with cotton twine. Net spreads disappeared with the invention of nylon nets. This photograph was taken around 1900. (MCHS.)

Members of the Stanton family came to Braidentown in 1884 aboard their steamer, *Manatee*. They brought with them sawmill equipment and began the Stanton sawmill at what is now Second Avenue and Fourteenth Street West. The Stanton home was built on the banks of the Manatee River with lumber from the mill. (MCHS.)

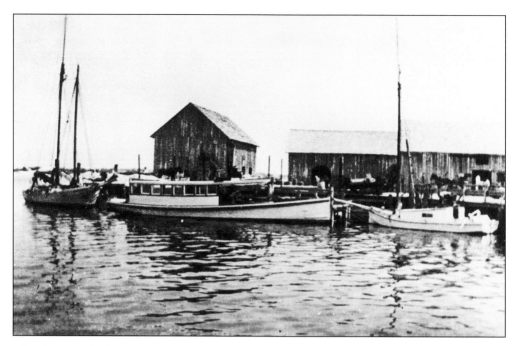

The photograph above paints a peaceful scene of boats moored at Corwin Dock. Horses are on the dock at right. Corwin's Dock, at the end of Main Street, was a busy place in the early 1900s. Ships running between Tampa, St. Petersburg, and the Manatee Section made regular stops for cargo and passengers. The Gulf Oil Company built its first warehouse on the dock. Below, trucks carrying barrels marked Gulf Refining Company deliver their load. (Both, MCHS.)

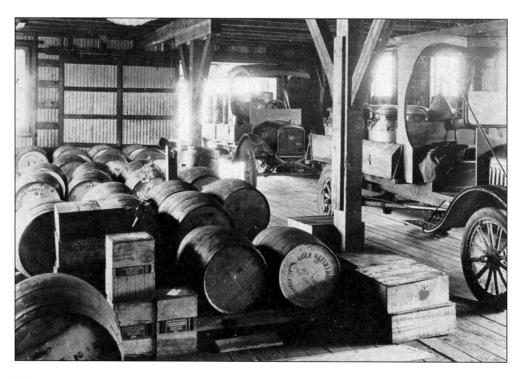

This driveway leads to Reasoner Brothers' Nursery, the oldest nursery in Florida. The nursery opened in 1883 and is still in business today. The Reasoner brothers are credited with propagating the first pink grapefruit in Oneco. They shipped some to Texas, where the fruit became very popular. The soil found in the Rio Grande Valley created a much deeper pink color. (MCHS.)

African American commerce occurred in a segregated section of Manatee that eventually grew into a bustling black neighborhood. In Bradenton, Ninth Street became the black section, complete with stores, offices, funeral homes, and a movie theater. (MCHS.)

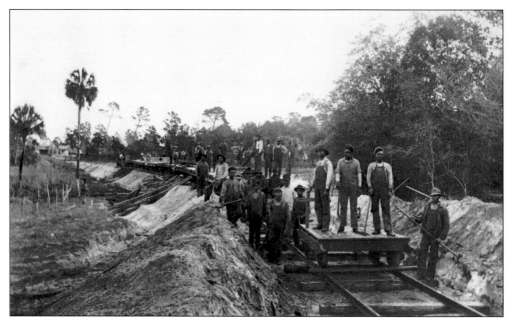

Around 1900, the Arcadia Gulf Coast & Lakeland Railroad (AGC&LRR) planned to construct a span from Sarasota to Lakeland with a bridge that crossed the Manatee River. The engine was floated to Braidentown via barge, and hundreds of residents watched as the engine was unloaded from the barge. The project went defunct, and the construction pictured was never completed; the partial span (above) got the nickname "The Slow and Wobbly." (MCHS.)

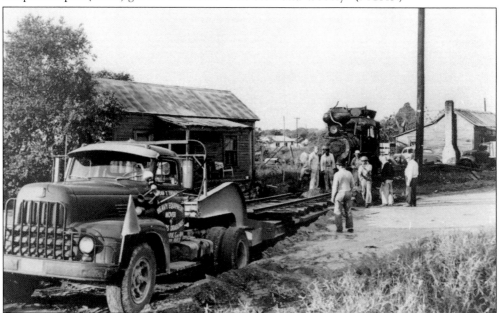

The Manatee Crate Company manufactured crates for shipping crops. It was run by steam and electricity and was the largest of its kind in Florida. The quarters for mill employees were known as "Punkin' Center." By the 1940s, 400 people worked at the mill for an average of 75¢ an hour. The mill closed in 1952, but a 1913 wood-burning locomotive known as "Old Cabbage Head" was salvaged (above) and was later moved to the Manatee Village Historical Park. (MCHS.)

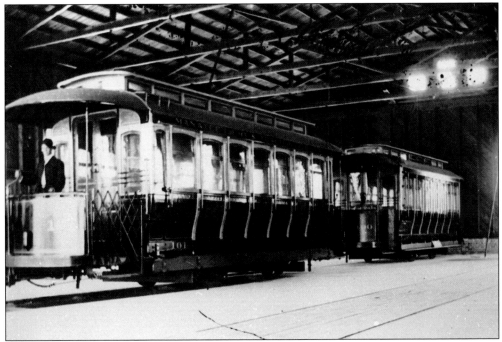

Above, streetcars are parked at the Manatee Light & Traction Company's barn in the rear of the plant. The main purpose for the power company, founded by John A. Graham in 1903, was to run a trolley line from Fogartyville through Braidentown and on to Manatee. Passengers and freight traffic were seasonal. Below, Main Street in Bradentown is lined with tall buildings and streetcar tracks and trolley wire for the Manatee Light & Traction trolley. This view looks south from Turner Street (later Third Avenue). The trolley line failed in 1906, and the tracks were taken up. (Both, MCHS.)

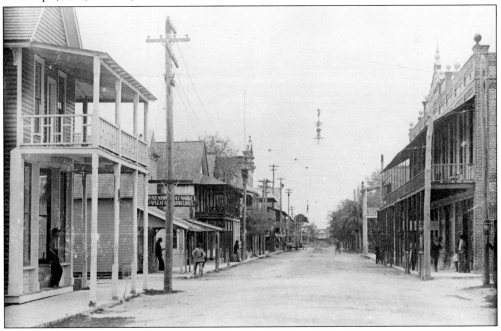

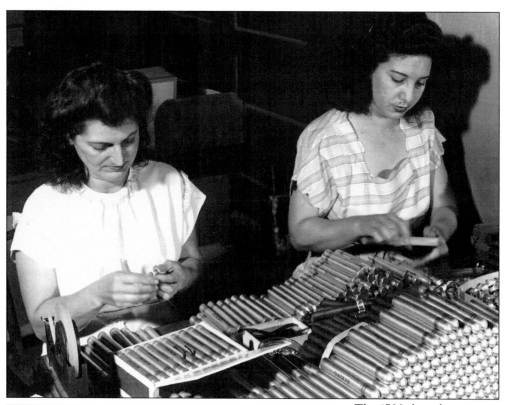

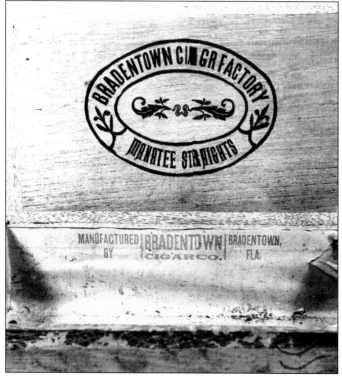

The 1700s have been referred to as the "Age of Snuff." Tobacco from North Carolina was used for snuff and pipe smoking, but when settlers moved to Florida, the era of Cuban trade had a big influence on the region, and cigar smoking became a favorite pastime for locals. Tobacco was a common crop for community farms, but Bradenton had visions of becoming the cigar capital of the South. Above, members of the Bradenton Cigar Company roll cigars known as "Manatee Straights." At left, a box of Manatee Straights includes "cigar" misspelled as "ciagr." Much like Key West, the town lost out to Tampa in the cigar business.

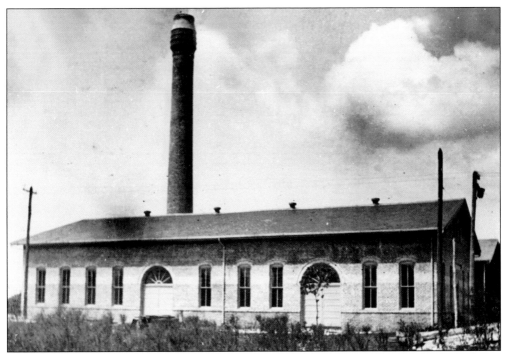

In 1903, John A. Graham built Bradenton's first power plant, Manatee Light & Traction Company (above), on the north side of what is now Third Avenue and Tenth Street West. It powered a trolley that ran from Manatee to Fogartyville. The company was later expanded into the Manatee Electric Company. Graham sold the business to Southern Utilities, and then Florida Power & Light Company purchased it as the Florida boom approached in the 1920s. The original building served as the local power source through the 1940s. The interior is seen below. (Both, MCHS.)

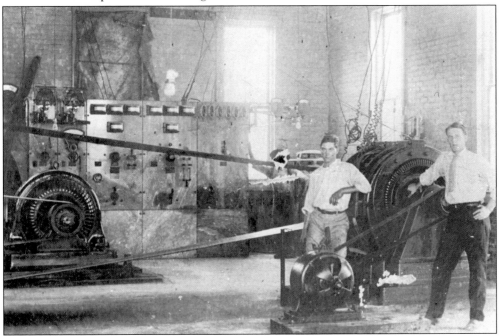

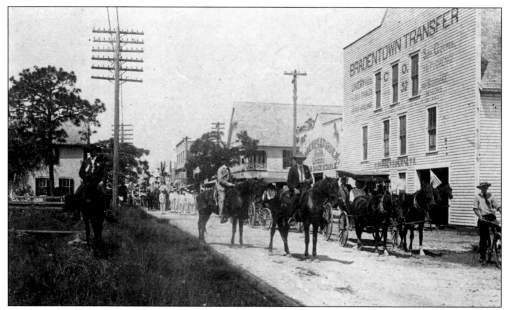

The second building on the right in this photograph of a parade down Manatee Avenue is the Coarsely Burnett Livery Stable, which doubled as a grocery. Burnett was a successful businessman and a natural cattleman—he was literally born in a covered wagon in 1871. He lost much of his fortune during the stock market crash of 1929, afterwards advising others "not to invest in stock unless it had hair." (MCHS.)

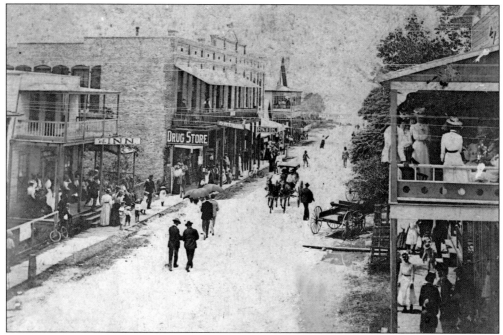

Main Street is seen here in 1904 with the Gaar House in the foreground. A portion of the home served as the first area hotel in 1890. The downstairs was rented to the county as a courthouse for $300 a year. In 1896, Volney A. Gaar purchased the hotel, and in 1908, he bought the Coe House next door and adjoined the two structures. The hotel was sold and torn down in 1984. (MCHS.)

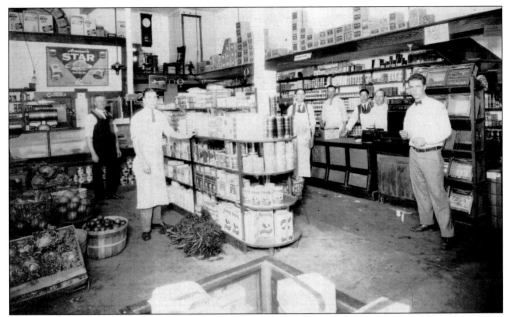

Penn Cash Grocery Store opened in 1916 and was considered the area's "supermarket," selling everything from washboards to fresh produce. In the 1930s, the shop became known for stocking health foods. The central location on the corner of Eighth Avenue and Thirteenth Street West allowed for goods to be delivered to area homes by motorcycle. (MCHS.)

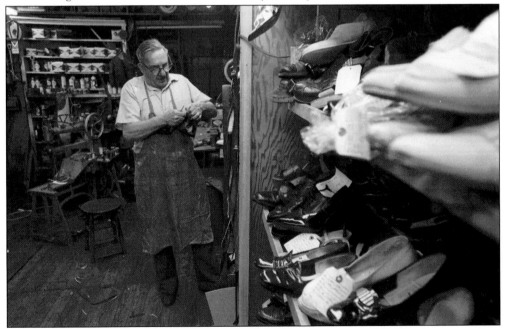

Joseph Potter owned the City Hall Shoe Repair Shop on Thirteenth Avenue West for more than 50 years, taking proprietorship in 1939 after his predecessor, Henry Gilmore, retired. Because it was conveniently located across the street from the original city hall, officials routinely used the shop restroom after lunch. Rumors circulated that Potter stocked the linen cabinets with a variety of liquor. David Potter took over the shop in 1980. (MCHS.)

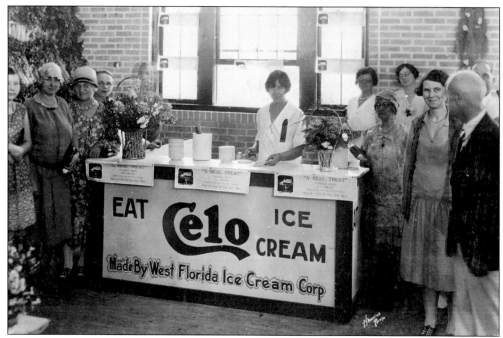

Celo was a soft drink made from local celery crops. According to the slogan, it "calmed the nerves." The Celo Company prospered in the 1920s with the support of local investors. In this photograph, members of the West Florida Ice Cream Corporation, a Sarasota-based company that opened in 1926, offer residents a taste of Celo-flavored ice cream at the Manatee County Fair. Despite promotional efforts, Celo never gained popularity outside the county. (MCHS.)

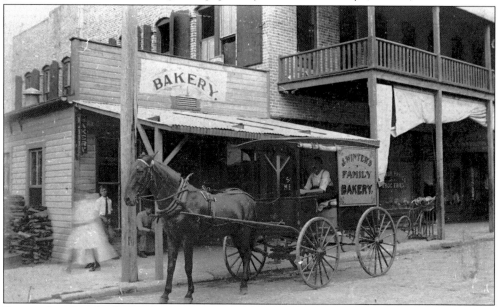

Because bread and cake products were perishable, proximity to a customer base was a primary concern. One way growing bakeries overcame geographic constraints was by setting up shop on busy thoroughfares and offering delivery service. Winter's Family Bakery was located on Main Street. In the early 1900s, a horse-drawn cart delivered baked goods all over the town. (MCHS.)

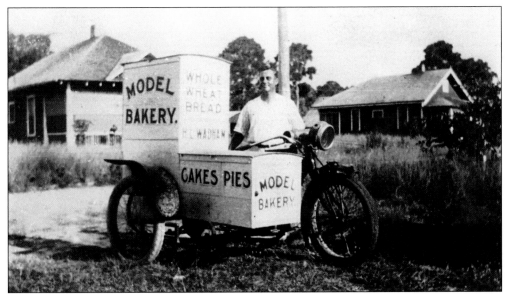

Harry L. Wadham, the owner of Model Bakery, is seen here with his delivery cart, which was built from a three-wheeled motorcycle. Model Bakery was originally located on Twelfth Avenue West but then relocated to Fourteenth Street West. His wife, Mara Wadham, baked their decadent goods. (MCHS.)

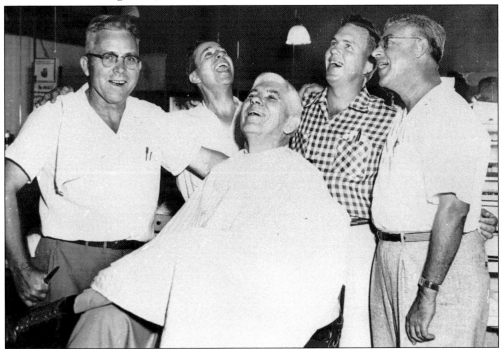

Cecil S. Lippard of Palmetto and Wilfred F. Sullivan of Bradenton originally ran the Royal Palm Barber Shop on Pine Street (later Thirteenth Street West). From 1945, G. Willard and George D. Howard and family owned it. Customers were often serenaded by a barbershop quartet. By 1974, it was owned by J.W. Cottrell. Recognizable in this photograph are Bill Howard, R.G. Roberts, Harper Kendrick, and Raymond Turner, who sing lustily. (MCHS.)

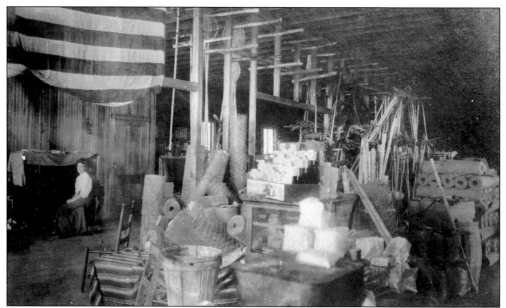

Proprietor Maj. Alden Adams claimed his mercantile store on Manatee Avenue stocked "everything you could ask for." Once, a traveling salesman wagered $10 that he could name an item not on the inventory and asked for a Methodist pulpit. By chance, Manatee Methodist Church was being remodeled, and Adams had supplied the furniture. In 1897, the store was set ablaze, and Maude Davis saved Major Adams from the fire. The two were married the following year. (MCHS.)

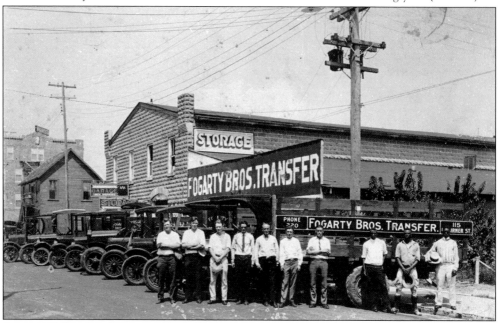

Since 1880, brothers Henry and Robert J. Fogarty had been active in transporting goods such as hogs, cattle, salted mullet, sweet potatoes, citrus, and other produce to Key West and other markets. In 1912, the Fogarty brothers started a trucking business called Fogarty Brothers Transfer, Inc. It was in operation until 1955, when they sold it to Great Southern Trucking Co. The Fogarty name is still used today. The entire staff posed for this photograph in 1925. (MCHS.)

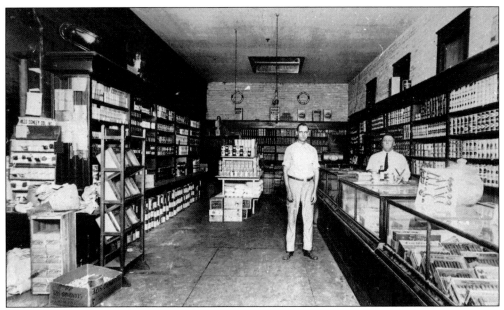

The interior of K.W. "King" Wiggins's store in Manatee is seen here. It was on the west end of the Davis Block, at the northwest corner of Manatee Avenue and Ninth Street West. He moved to the location from his original store, a small portion of which was incorporated into the Manatee Village Historical Park. The building was restored and porches were added. (MCHS.)

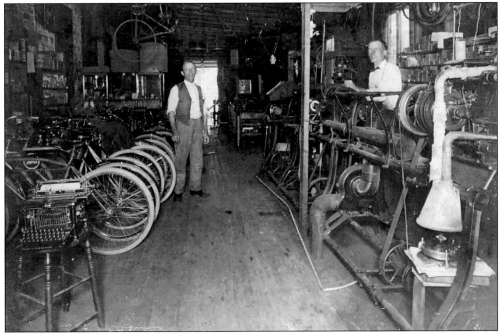

The interior of Kretschmar's Bicycle Shop, which was located on the west side of the Iron Block on Manatee Avenue, is seen here. The shop was split and included Taylor's Shoe Shop on the right. Ernest Kretschmar and Roy E. Taylor are seen inside. Kretschmar also ran a ferry across the river between Braidentown and Palmetto. It was a naptha gas–engine launch called *Zephyr*, which he owned for many years. (MCHS.)

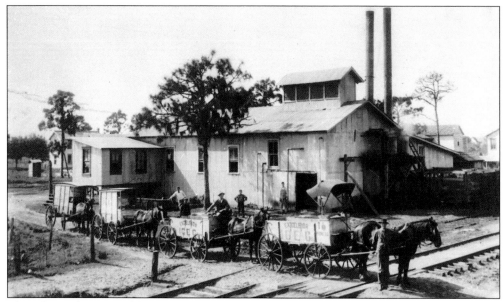

These horse-drawn ice delivery wagons are in front of the Excelsior Ice Company at 115 Beach Street. A heavy-duty motor operated the machinery. It was so powerful that it shook the houses in the immediate vicinity when in operation. At night when the motor ceased, it awoke everyone in the neighborhood. At the top of the plant, a siren alerted the public of fire. The plant was in business for more than 20 years. (MCHS.)

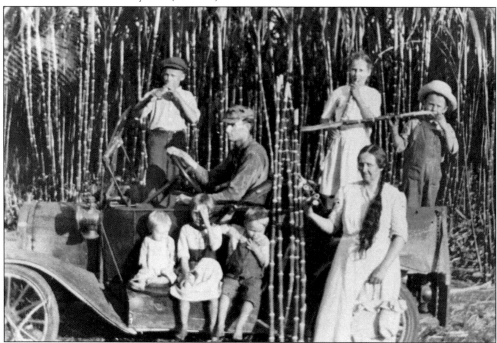

Members of the James A. Felts family of Palma Sola are seen in their sugar cane field before the harvest. Posing here are, from left to right, (first row) children James, Idell, and Otis Felts, Mr. Ferguson (driving), and mother Melinda Idell Prince Felts; (second row) Frank Felts, Beulah (Ward) Felts, and Herman A. Felts (in light hat). (MCHS.)

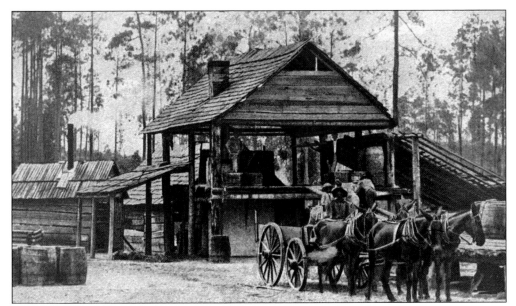

For many years, counties had very small jails because they rented out their prisoners to turpentine camp operators, who had to shelter and feed the prisoners while paying the counties as much as a dime per day. In 1915, after the East & West Coast Railroad was built from Manatee to Arcadia, many turpentine stills and sawmills sprang up east of Braden Creek. (MCHS.)

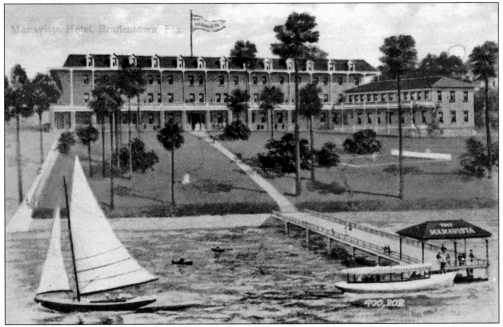

The Manavista Hotel, constructed in 1905, was the oldest of the large Bradenton hotels. It is seen here with part of its garden along the Manatee River. It was located at the foot of Bradenton's Old Main Street and was owned and operated by J.L. Tallevast. In this postcard view, the hotel is seen from the river. The dock and canopy are ready to welcome visitors coming by sailboat or steamship. The three-story brick building is visible in the photograph as well as the two-story addition. (MCHS.)

In 1914, Mary Ward and her two children settled on Manatee Avenue and Twenty-sixth Street. Previously a pottery artist, Ward discovered a clay deposit at the 2700 block of Riverview Boulevard and started a business—Manatee County's first artistic commercial endeavor. The clay had a distinct blue color that became neutral after firing. Candlesticks, bowls, and vases were adorned with Florida birds, palmettos, and palms. A body of water was exhibited on each piece. The pottery served mainly decorative purposes. Production was first done in the back of a house in Fogartyville; one wheel was run by electricity, and the other three were run by foot-pumps. Ward's pottery was marketed all over the country. She set up a small shop in downtown Bradenton. In 1921, she sold her interest to Henry A. Graack and moved to Orlando, where she started Orlando Potteries. Below, Ward and workers pose with pottery. (Both, MCHS.)

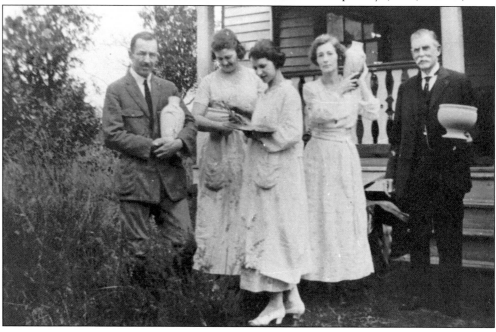

The Manatee River Hotel is pictured as it looked on June 24, 1926. Railroad money from the Van Swerigen family built the hotel in 1925. No expense was spared during construction of the $1.4-million hotel. Because steel beams supported the entirely concrete structure, it was considered fireproof. Construction took three years to complete because of the lavish decorations. It featured 200 staterooms, four exclusive tower studios, several ballrooms for social events, and a rooftop garden with a dance floor where celebrities danced the Charleston, toasted bootlegged champagne, and sipped infamous Manatee moonshine. A-listers like Rita Hayworth, Clark Gable, Tyrone Power, Babe Ruth, Al Capone, Dizzy Dean, and Herbert Hoover were allegedly guests at the upscale resort. It was turned into a retirement home in the 1960s and then abandoned in the 1990s. (Both, MCHS.)

Anthony T. Rossi (above, 1900–1993) immigrated to the United States from Sicily when he was 21. He settled in Palmetto and began packing fruit gift boxes under the name Manatee River Packing Company. As the business grew, the company moved to East Bradenton and became Fruit Industries, supplying the ingredients for, among other things, the salads at New York's famed Waldorf-Astoria Hotel. Rossi produced frozen concentrate orange juice and in 1954 developed flash pasteurization, a process that preserved the fresh taste of the juice. The photograph below shows a laboratory at Tropicana. In 1957, the company's name was changed to Tropicana Products, Inc. By 1958, a convoy of refrigerated trucks transported goods nationally, and the SS *Tropicana* (above) was shipping 1.5 million gallons of juice to New York each week. In 1969, Tropicana became the first company in the citrus industry to operate its own plastic container manufacturing plant. Rossi sold Tropicana to Beatrice Foods in 1978 and retired. He was inducted into the Florida Agricultural Hall of Fame in 1987. (Both, personal collection.)

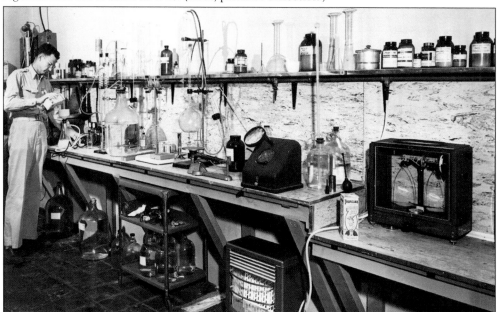

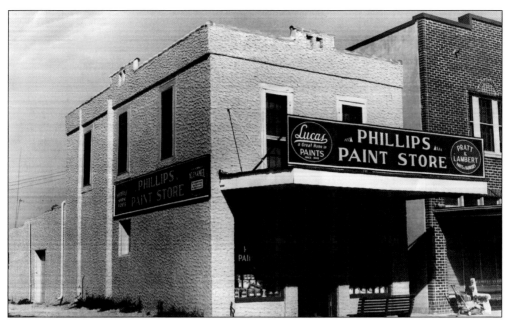

When James Robert Phillips ran away and joined the Marines, his mother, Thelma Posey Phillips, was distraught—he was her only son. She wrote to his commandant every month asking that he be dismissed. Despite his mother's pleas, Phillips was sent to Iwo Jima for Operation Detachment. His father, Carl Phillips, who feared for his wife's well-being, ran a commercial painting company but decided to rent a storefront (above) and hired Thelma as the receptionist so he could keep an eye on her. Because the headquarters were centrally located on Main Street with display windows, onlookers assumed it was a retail business. After a wave of customers came in wishing to buy paint, the couple decided to go retail. When their son returned, he worked in the shop with them (below). Phillips Paint Store was in business for more than 20 years. (Both, Marianne Barneby.)

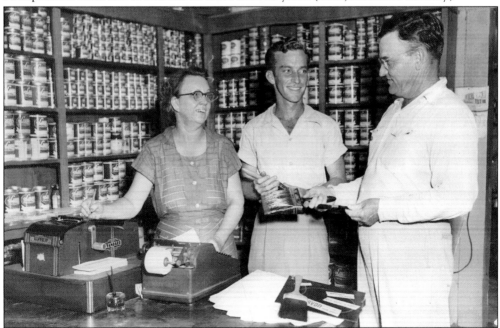

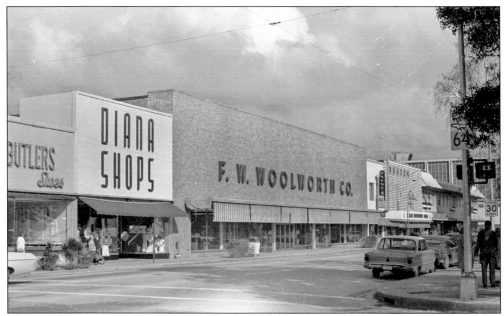

Diana Shops, seen in this 1950s view of Manatee Avenue, gave hope chests to graduating girls, while a marketing ploy at Woolworth's (right) guaranteed any kid a banana split. In the promotion, balloons were tied to a string stretching the length of the soda counter. Inside each balloon was a price, descending to one penny. Customers ordered their banana split and then chose a balloon, which the waitress popped, writing the ticket based on the price tag. (MCHS.)

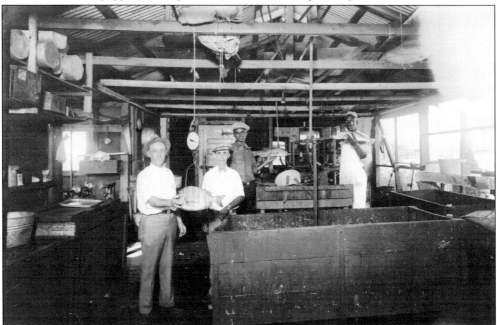

Hawker's Fish Market was first located on the Corwin Dock, but the building was destroyed in a fire in December 1915. The business relocated to Ninth Street in Bradentown. Here, Everett Hawker (front left), Herman Seeding (front right), and two workers hold up some of their inventory. Hawker's remained in business into the 1990s. (MCHS.)

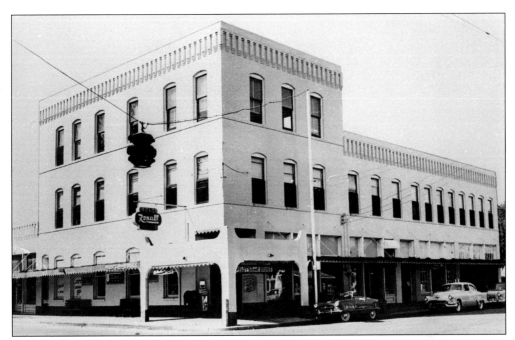

Manatee Drug Company changed its name to Pelot's Pharmacy in 1925, and in 1934, it moved from the Central Hotel to the vacancy left by the Manatee County Supply Company in the Davis Building, at Manatee Avenue and Central Street (later Ninth Street East, above) in Manatee. Pelot's is still in business today. (MCHS.)

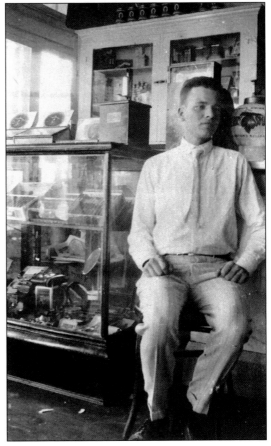

This unidentified man poses inside Manatee Drug Company. The company's founder, Dr. John Crews Pelot, graduated from Jefferson Medical College in Philadelphia in 1858 and later became an assistant surgeon at Andersonville Prison. Dr. Pelot moved his family to Manatee in late 1865. He started Manatee Drug Company in 1894, and the name was changed to Pelot's Pharmacy in 1925. Four generations of Pelots have owned the business. (MCHS.)

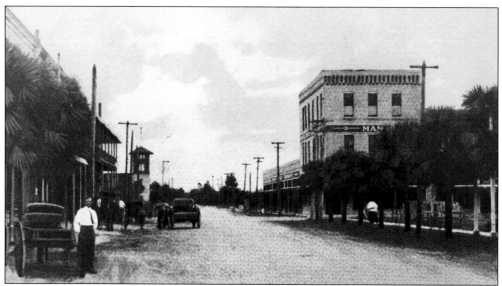

Manatee Avenue in Manatee is still shell-paved in this early view. The tower in the center is part of Maj. Alden Adams's dry goods store. The tall stone building on the right is Manatee Drug Company, John J. Pelot, proprietor. Only carts and wagons occupy the road, although automobiles were seen on the south side of the river beginning in 1903. (MCHS.)

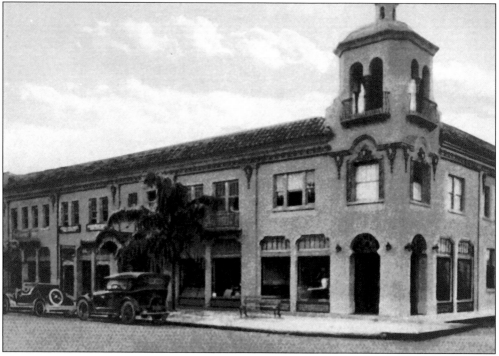

The Arcade Building, which housed the Manatee Post Office, is seen here. The building was 110 feet by 110 feet and made of hollow stucco tile. The Manatee Arcade Company, composed of local investors, owned it. The architect was J.H. Johnson, ground was broken on April 24, 1925, and the building was completed in 1926. The Arcade also housed a drugstore, a grocery store, an insurance company, and a doctor's office. It was torn down in 1978. (MCHS.)

Jay Hanna "Dizzy" Dean, at right, was one of the most notorious baseball characters from the area. He was known for his practical jokes and pranks and for sending the press on wild goose chases. Dean eventually retired to Bradenton, where he and his brother ran a filling station across from the Manatee River Hotel on Tenth Street West in Bradenton. (MCHS.)

John T. Campbell is behind the cashier's window and, from left to right, Ernest Kretchmar, Furman Whittaker, and H.C. Stansfield are inside the Bank of Manatee in Braidentown on the day it opened in the Warren Opera House building: January 1, 1900. The first day of business brought $26,000 in deposits from 44 people. In 1912, the name was changed to First National of Bradentown, and in 1974, it became Ellis First National Bank. (MCHS.)

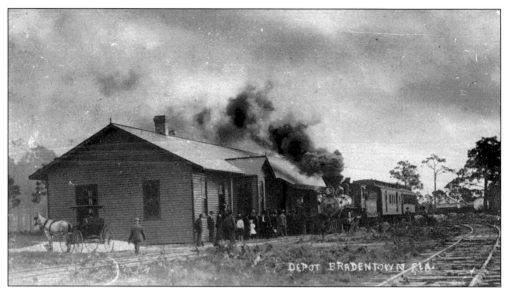

The Seaboard Airline Railway Company (SAL) opened the first bridge across the Manatee River on December 12, 1902. For promotional purposes, SAL officials scheduled the completion on the 12th day of the 12th month and had 12 railroad cars cross the bridge, each with 12 passengers in them, at 12:00 p.m. The station in Manatee is seen here. (MCHS.)

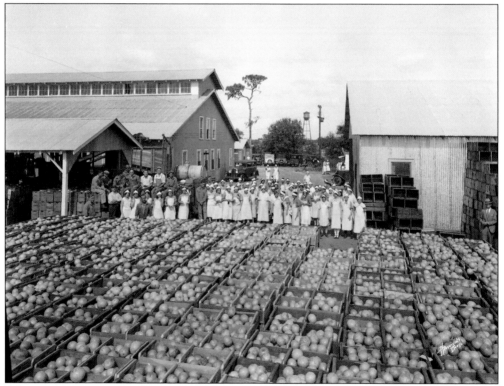

After citrus was introduced to Manatee County, it played an important role in the economy. At first, the fruit was processed by hand. Here, employees of the Domino Citrus Association plant in Bradenton pose for a group portrait in the late 1920s. (MCHS.)

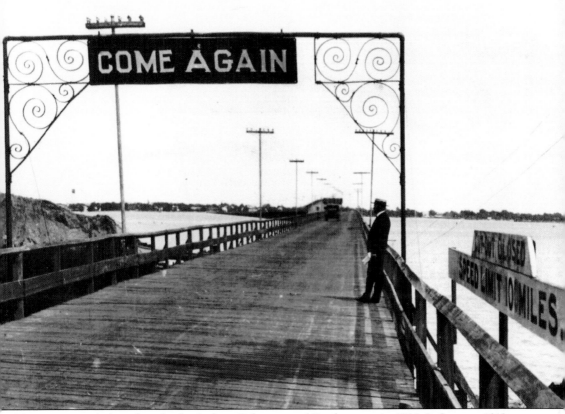

Voters approved plans for a bridge linking Palmetto and Bradentown in 1916. In January 1918, construction was postponed due to complications from World War I, but in October, 37 tons of steel arrived at the dock. Workers assembled the steel on barges and floated them into position at high tide. Construction was completed in August 1919, and it was named Victory Bridge. A "Come Again" sign hangs on the Bradentown side. (MCHS.)

Car traffic eventually became a problem on the wooden Victory Bridge. On October 30, 1924, a new bridge contract was arranged. Work began in January 1925, but construction was not completed until June 1927. With the creation of roads and railways, the need for river cargo ships diminished. By the 1970s, the draw only opened about 25 times a month. Here, the bridge tender reads a book to pass the time. (Personal collection.)

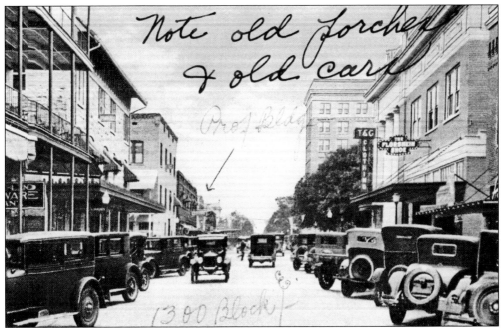

In 1915, businessman Robert M. Beall Sr., then 22, opened a dry goods store called the Dollar Limit on Main Street in Bradentown (above, an arrow points to the location). Beall spent his entire investment of $2,500 on stock, so he repurposed wooden packing crates in which the goods had arrived and used them as display tables. All merchandise was under $1. As inflation increased, the name changed; in 1918, the store became the V (Five) Dollar Limit. Beall intended to expand but lost everything during the Great Depression. He kept the bank-owned store in operation. In 1940, Beall's son, E.R., joined him. Together they were able to purchase the store back piece by piece. In 1946, they changed the name to Bealls Department Store. In 1970, E.R.'s son, Robert M. Beall II, joined them. All three generations were active in the company (below) until Robert Sr.'s death in 1979. Today, Bealls includes over 535 stores all over Florida. The original downtown location operated until 1987, when it was torn down for new construction. (Both, Beverly Beall.)

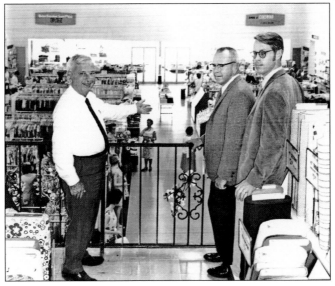

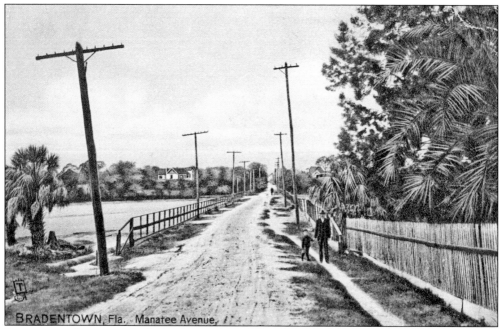

BRADENTOWN, Fla. Manatee Avenue,

Here is an early view of the Manatee Avenue Bridge across Ware's Creek. Until its construction in 1887, early settlers rowed or sailed small boats along the Manatee River to commute to various settlements. The Jacque's Creek Bridge, along with the Ware's Creek Bridge, completed Manatee Avenue, connecting Manatee Village with Fogartyville. The fence along the bridge was used to keep the town's free-roaming cattle out of the residents' yards and gardens. (MCHS.)

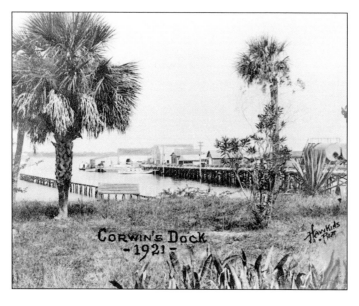

CORWIN'S DOCK
-1921-

The dock to the Manavista Hotel and the Corwin Dock with its commercial buildings are seen in this 1921 photograph. Corwin Dock was the hub of river commerce for Bradentown and was located at the end of Main Street. One of the most fruitful businesses located on the dock was Ernest "King" Wiggins's packinghouse. In the 1920s, railroads took over shipping from steamers, and the boat lines were discontinued. The dock and the packinghouse were eventually razed. (MCHS.)

Four

LIFE AND TIMES
ON THE SOUTH SIDE

The social life of settlers centered on church. On Sundays, families piled into horse-drawn wagons and journeyed to town, providing a pleasant interlude to the backbreaking work that filled the rest of the week. Many families lived in desolate locations, and even a 10-mile trip to church on rutted roads seemed a minor inconvenience considering the reward: a day spent fraternizing with friends, neighbors, and family. While daytime services were often long, singing hymns and nighttime revivals broke the tedium and entertained the entire family. After worship, the women of the congregation unloaded brimming baskets and tubs filled with homemade specialties for potluck dinners on the church grounds. Men would often roast a hog over an open fire.

Sundays were reserved for prayers and spiritual matters, but during the rest of the week, the settlers seldom lacked for leisure pursuits. Fishing has always been a particularly popular pastime and the sandy shores and tidal pools along the river harbor offer a supply of fiddler crabs, sand fleas, and shrimp to use as bait. Poles were made of cane, and nets were crafted from cotton twine. The local bays and bayous held scallops, oysters, crabs, and clams. It was common for families to camp on one of the many cays and roast their catches on screens set over an open fire. Another treat was to pack a picnic lunch for boat excursions to Anna Maria, Egmont Key, or Shaw's Point, all popular swimming and picnicking spots.

Isolated from town and neighbors as they were, settlers seeking camaraderie formed social clubs, one of the oldest being Manatee Lodge No. 31, which was chartered on January 14, 1853, and held its first meeting on the third floor of Josiah Gates's home. The first worshipful master was Franklin Branch, and the first senior warden was Joseph Braden.

School served both an educational and a communal role. At first, schools were held in the homes of residents. Rev. Edmund Lee and his wife, Electa, converted the upstairs floor of their home into a schoolroom where Electa enrolled students for $5 per term. The school was called the Dame School for Boys. In 1876, the Lees donated a portion of their land for the first advanced school in the county, Manatee Academy. Farming families preferred local-season strawberry schools, which began popping up all over the county, allowing children to still be able to help their parents when it came time to harvest the crops.

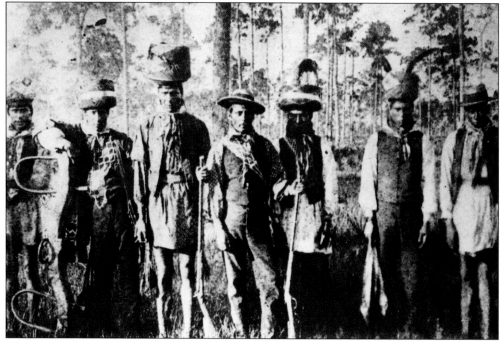

This party of Seminole hunters poses with their hunting rifles and an ox yoke. Most of them are wearing traditional hunting shirts, while others are dressed more causally. Recognizable in the group, in no particular order, are Billie Stewart, Cuffee Gopher, Tom Billie, Jimmie Osceola, Billy Buster, and Charlie Dixie, whose mother was a former slave and was later received as part of the Seminole Bird Clan. (MCHS.)

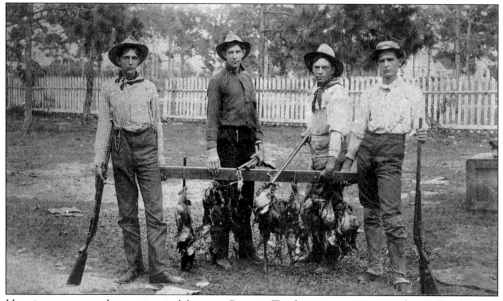

Hunting was a popular pastime in Manatee County. Tracking game meant exploring Bradenton's pristine environment and bringing home dinner for the family. Here, from left to right, John F. Vanderipe Sr., William H. Vanderipe, John Lane, and Henry Curry pose and display their game birds after returning from a successful hunting trip. (MCHS.)

Before a bridge connected Anna Maria Island to the mainland, it was a popular camping spot, and equipment was transported by boat. Tents were made of canvas and leaked during thunderstorms, never seeming to dry out. Campers did not have the luxury of coolers or mosquito netting, and food had to be foraged in the bug-infested terrain. These two men enjoy a breakfast of fish and grits on the beach. (MCHS.)

As a joke, someone placed a stuffed alligator at the Corwin Dock in 1915, which gave the hundreds of visitors a freight as they disembarked from steamers. Once they realized it was not aggressive, they posed with the gator for a souvenir to send friends and family back home. At the foot of the dock was Twelfth Street West. Curry Point is in the background. (MCHS.)

Adorned in sunhats to protect their faces from the sun, this group of young ladies enjoys an afternoon row on the Manatee River in the early 1900s. Leila and Hattie Curry and Blanche Alderman are some of the people in the boat. It was not uncommon for girls in the area to take boats out by themselves; in most cases, rowing to a destination was the most efficient means of transportation. (MCHS.)

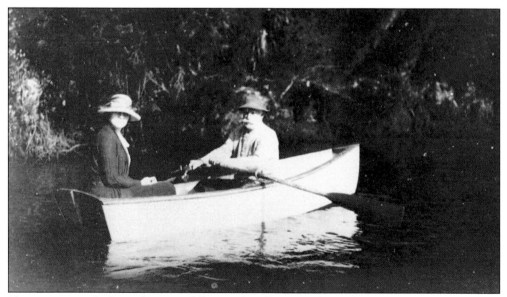

If a woman were lucky, a charming fellow might offer to row her to her destination. In this case, Capt. Bat Fogarty, the proprietor of the Fogarty Boat Works, rows a woman across the water. The small boat is designed in the style of the wooden boats he often built at his shop. (MCHS.)

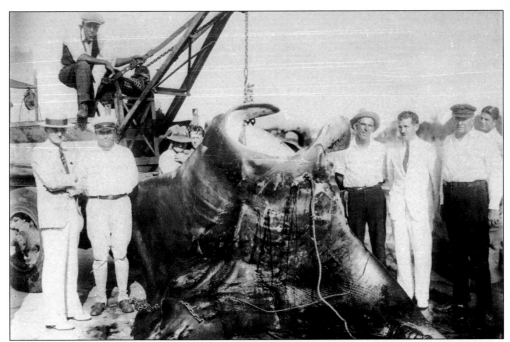

Imagine how startled early settlers must have been to see a giant manta ray jump completely out of the water while they rowed along the serene Manatee River. Anglers were intrigued by the large creatures, which they called devilfish. The fishermen above hooked and landed this 3,500-pound manta ray off of Longboat Key. It was 15 feet wide. (MCHS.)

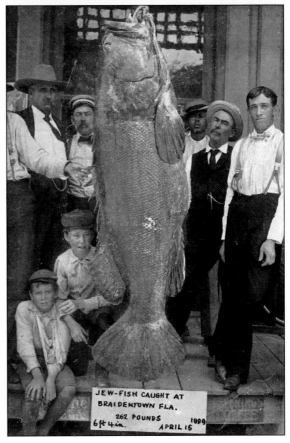

Goliath grouper, or jewfish, are common in Florida and are found around docks, in deep holes, and on reefs. In the past, anglers lured these giants with a live mullet and a strong line. Here, six men stand behind a goliath grouper they caught near Braidentown. The man on the left is believed to be Sheriff Thomas R. Easterling. (MCHS.)

Lynn Willis and Hubbard Fogarty do not look too sure about taking the reins on the back of a tarpon in this photograph. While sitting on a slimy fish was not the ideal situation for the two toddlers, their parents presumably thought it would make a cute picture. (MCHS.)

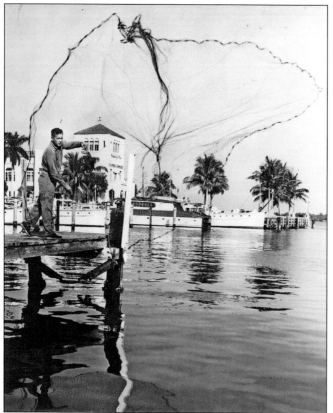

Fishing with a cast-net has always been a popular pastime in the area. Local fishermen, both recreational and commercial, traditionally maintained several nets of varying sizes, lengths, depths, corks, and weight placements. The different nets were used depending on the species sought. Here, Ralph Parrish throws a perfect cast off the dock at Bradenton Marina. The municipal pier is in the background. (Personal collection.)

Manatee Methodist Church was established in 1849, making it the oldest church of any denomination south of Tampa on Florida's west coast. John W. Curry, Ezekial Glazier, and James G. Cooper purchased a lot for the church in 1866. It is believed that the church ownership of that site represents the longest private ownership of land in Manatee County. The church is now in Manatee Village Historical Park. (MCHS.)

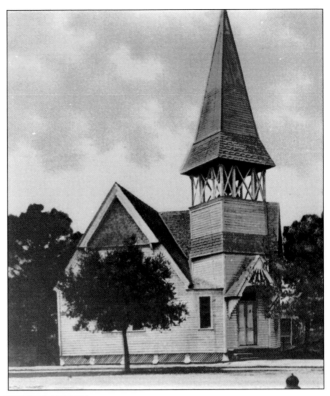

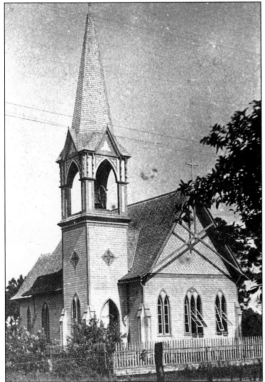

The original First Baptist Church of Bradenton was made of wood. In September 1920, the first meeting of the Women's Christian Union was held inside. Just as the meeting was adjourned for a potluck supper, a lightning bolt struck the steeple and set the church afire. The men of the community were a bit nervous, and they wanted to know exactly what had gone on during the assembly. (MCHS.)

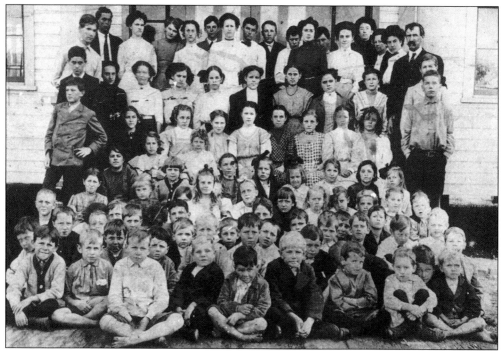

The first advanced school in the county was Manatee Academy. In 1876, Rev. Edmund Lee donated a portion of land specifically for educational and cultural purposes. The one-story school had a traditional bell tower and a loft that served members of the Grange and Freemason clubs. It was taken over by the school district in 1895. A three-story brick building replaced the old wooden structure in 1912. (MCHS.)

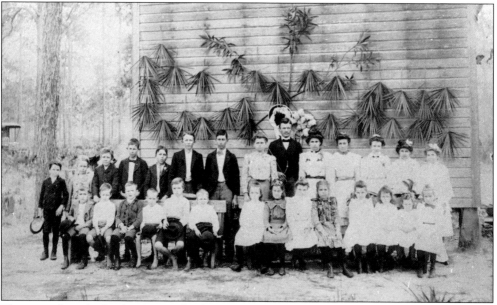

This group from the Braden River School includes Gib Johnson, Gradon Johnson, Lucian Kennedy, Luke Kennedy, Bud Pope, Tom Kennedy, Prof. H.M. Frazee, Inez Johnson, Lula Kennedy, Dora Kennedy, Ida Kennedy, and Leticia Kennedy. The boy seated in front is Henry Johnson. (MCHS.)

Small strawberry schools opened in eastern regions around the 1880s. Classes ran from April through December, allowing children to help their families harvest crops. The old Bunker Hill School, seen here, was placed in the Manatee Village Historical Park and restored. (MCHS.)

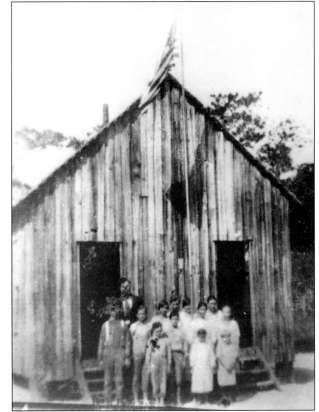

By 1924, there were 28 one-teacher schools in the county. Six schools employed two teachers, and there were 13 campuses with between three and 15 teachers. Bradenton Elementary School was one of the bigger schools. Below, students are lined up outside. (MCHS.)

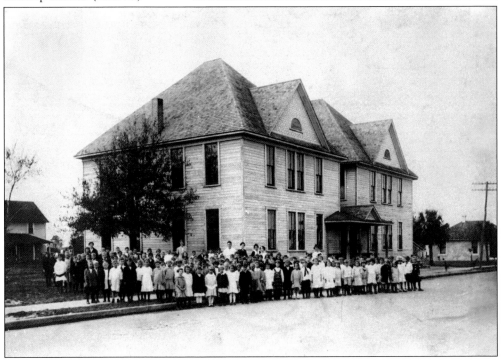

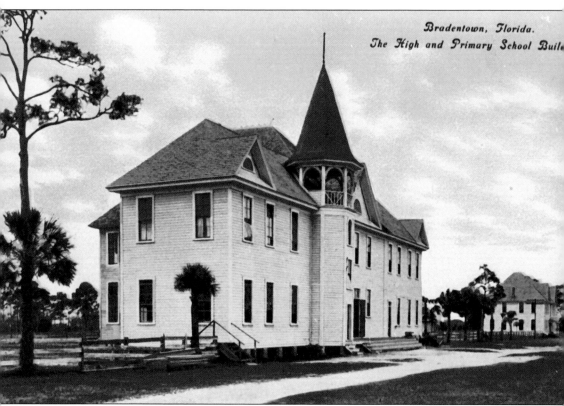

Bradentown, Florida.
The High and Primary School Buil

Garfield DeVoe Rogers established Lincoln Academy in 1930. He purchased a plot of land along Second Street and Tenth Avenue West and arranged for the original 1890 courthouse to be moved there and converted into a school. Unlike white schools that received government funding, Lincoln functioned through an exchange program. Bradenton High School donated old books and football uniforms to the students, and children and parents held fundraisers in order to buy equipment. When Lincoln first opened, its curriculum only went to an eighth-grade level. African Americans seeking a higher education traveled to one of five private academies located at all corners of the state. But by 1931, the school expanded to 12th grade. In 1948, it merged with Memorial High School in Palmetto and became Lincoln Memorial High School. The school's last graduating class received its diplomas in 1969. The following year, all underclassmen were integrated with other schools around the county. (MCHS.)

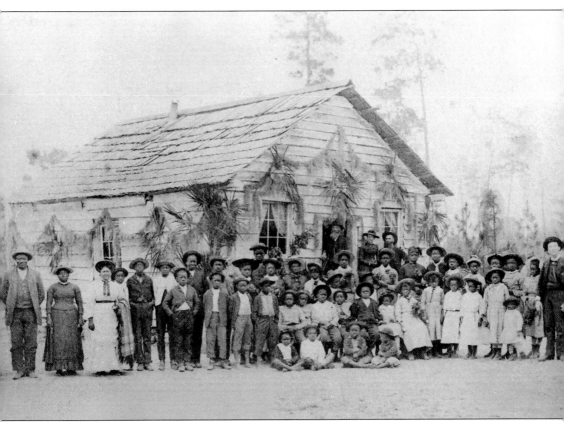

For years, Lincoln Academy was thought to be the first school for African Americans, but in 2006, Norma Dunwoody of the Family Heritage House Museum in Sarasota discovered a school that existed prior to Lincoln. Lyles-Bryant Colored School was on the 600 block of Eleventh Avenue East. From 1922 to 1931, students from all over Manatee attended the school, which was similar to the one seen here. The school taught kindergarten through eighth grade. It was named after two black residents: Jenette Lyles, whose husband was a prominent doctor, and businessman Louis W. Bryant. Documents show that Bryant was one of several members of the Colored Law and Order Organization, which was established in 1910 and helped procure the school's land. Other group members included president G.D. Rogers, Joe Allen, Alex Bristoe, Theodore Gordon Sr., Walker Stewart Sr., and Cleveland Williams. The organization sold seven lots that it owned, and the money was given to the Manatee County Board of Public Instruction. (MCHS.)

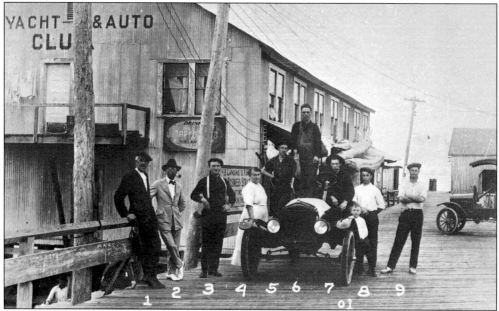

Above, Yacht and Auto Club members pose in front of their clubhouse on Bradenton's Corwin Dock. The club was on the west side of the dock at the foot of Bradenton's Main Street. It was built by Mr. Shaver and housed his Ford Automobile Agency on the first floor. The building's second floor was the clubhouse. The Curry brothers, Ed and Whitney, were members. Their family owned the fist automobile in Manatee County. In 1911, the Curry brothers won the Tampa to Bradenton Auto Race and the Race On The Sands at Daytona Beach. Below, Ed Curry balances the trophy upon the car's hood while Whitney Curry stands to the right, behind the boys in the car, holding the second trophy. The trophy from the car hood was in the Eaton Room of the Manatee County Central Library for many years. (Both, MCHS.)

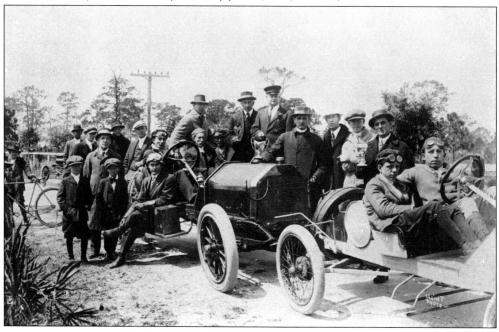

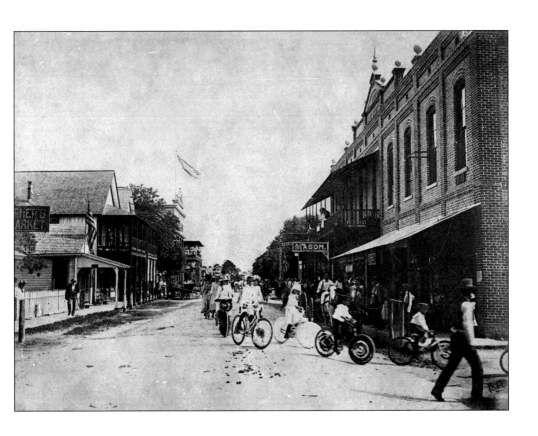

On July 4, 1910, Dr. H. Baer arranged for an exciting day of car and bike racing. People came from as far as Tampa to participate. For the first event, the cars made a mile dash with a standing start from Main Street. A Standard-Dayton 40 won with a time of one minute and 18 seconds. The second race was 60 miles. Above, spectators enjoy a bike race as they wait for the cars to return. Whitney Curry, below, won a grand prize of $100 in gold despite his penalty for colliding with a fence. His time was 1 hour and 30 minutes, and he drove William Warren's Buick Model 16. Gulf Oil presented the rest of the winners with drums of gasoline and cases of oil as additional prizes. (Both, MCHS.)

The Warren Opera House was advertised as "the finest theatrical building of the West Coast of Florida." The theater was located on Main Street in a brick building that was considered fireproof, even though the light fixtures inside were run on gas. There was enough seating for 700 people. The opera housed the First National Bank of Bradenton and the city's first telephone switchboard. Above, advertisements for local businesses cover the stage curtain. Below is the cast of *Pygmalion and Galatea* in full costume. Members of the Dramatic Club, under the direction of C.W. Spicher, include in no particular order, C.W. Spicher, Harry Land, J.L. Collier, Marius Herrin, J. Van, Hilda Curry, Emma Tyler, Laura Wyman, Mara Harria, and Nettie Simmons. (Both, MCHS.)

The 1914 Manatee County High School football team poses for a team photograph. Known as the Manatee Maroons, they became state champions the following year when they beat Gainesville High School 10-0. The team included, from left to right, (first row, kneeling) Taylor Scott, Kehr Knight, Irvine Parker, Arthur Johnstone, Arthur Tyler, Leon Amlong, Rupert Wyatt, Dan Coarsey, Clarence Armstrong, and Warren Johnson; (second row, standing) Raymond Rood, Mary Wyatt, Stanley Foss, Olin Gates, and J.C. Howard. (MCHS.)

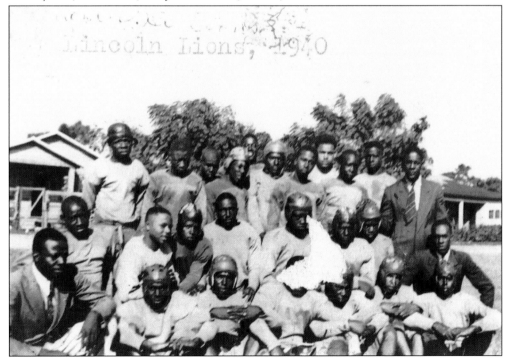

The 1940 Lincoln Academy Lions are seen here. Their uniforms were handmade and their sporting equipment was secondhand, donated from white schools. When Lincoln High School opened in Palmetto in 1948, the Trojan was adopted as the school mascot. (MCHS.)

The Manatee County High School girls' basketball team looks cool and confident in this photograph on the south lawn. The team included, from left to right, (first row) Elizabeth Tallevast, Edith Robertson, Marian Curry, and unidentified; (second row) Dorothy Fuller, unidentified, Alice and Cordelia Corwin, and Louise Easterling. (MCHS.)

The Bradenton High School girls' basketball team was South Florida champion in 1937. Recognizable in the photograph are (first row) coach Jimmy Hightower, Ruth Hampton, Leuna Perry, Marion Ridgdill, Edith Kennedy, Opal Jamison, Shirley Griffin, Clara Belle Balis, Georgie Gates, and manager Leonora Amlong; (second row) Jim Murphy, unidentified, Mary Lou Longino, Francis Alderman, Jessie Beth Longino, Morrell Albritton, Doris Snow, and Elanor Hill. (MCHS.)

Ballard Elementary School was built near Ware's Creek in 1922. It was constructed of fireproof brick and hollow tile and could accommodate 500 students. The original school had 16 classrooms and a separate auditorium with seating for 700. The Sue Stewart Annex was added in 1941. The old building was torn down in 2000, but the auditorium remained for use with the replacement building. The school was named for Dr. Charles Ballard, a supporter of local education. Dr. Ballard donated city lots as well as money to be given as prizes to the best students in Bradenton's eighth grade each year. The winning student could keep the lot as a future homestead, or the land could be sold, with the profit used as a college fund. Dr. Ballard also donated the land on which the 1912 Manatee High School building was built. (MCHS.)

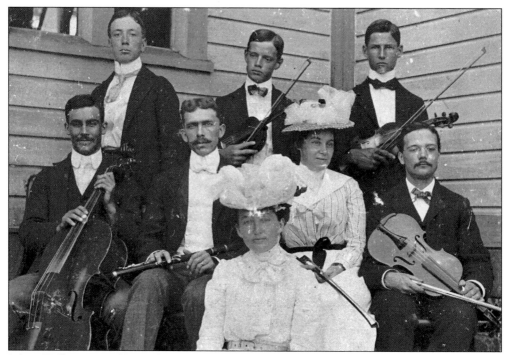

Johan Willemsen and his wife, Sara Jane, emigrated from Germany and made their way to the Manatee Section in the 1860s. Johan had dreams of starting his own colony, so the couple settled near present-day Twenty-sixth Street, a location they determined was just far enough from the town of Manatee to become a settlement. Johan Willemsen envisioned a wharf that would serve as the quay, where the couple planned to build a store. They planned to call their town Willemsenburg. Before the Willemsens could rightfully establish a village, the Fogarty brothers moved in, and their dreams were shattered. However, the townspeople catered to the Willemsens' inspiration and gave him naming rights to a school and church after he donated the land. Above, the church orchestra poses outside of the Christ Episcopal Church in Willemsenburg. Below is the Willemsen Academy, built in 1887. All the children of the area, including the Fogartys, attended the school. (Both, MCHS.)

This group of ladies from Braidentown poses with fans made from palm fronds and a book. Because of the hot atmosphere, most clothes worn during the summer were made from cotton. Women also commonly donned straw hats on a typical daily stroll to keep the sun off of their faces. (MCHS.)

The Manatee County High School radio club is seen below in 1923. The club worked with some of the most advanced radio equipment available at the time. The club included, in no particular order, Irving Parker, Oliver Turner, Glenn Miller, Henry Curry Jr., Marian Curry, Elizabeth Tallevast, Ted Lundy, Chelsea Griffin, Bernard Zoller, and Robert Miller. (MCHS.)

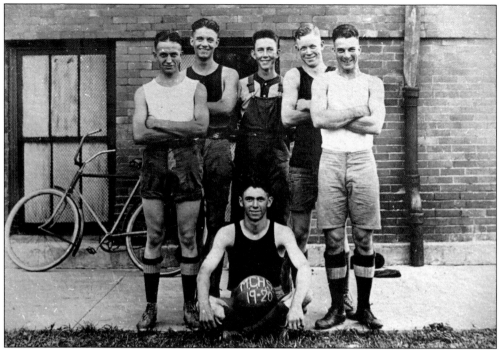

The 1920 Manatee County High School basketball included captain Garnet Puett (seated in front) and, from left to right, John Jenning, P.T. Dix Arnold, team manager Lorris Gates, Milton H. Wyatt, and Gilbert Johnson. (MCHS.)

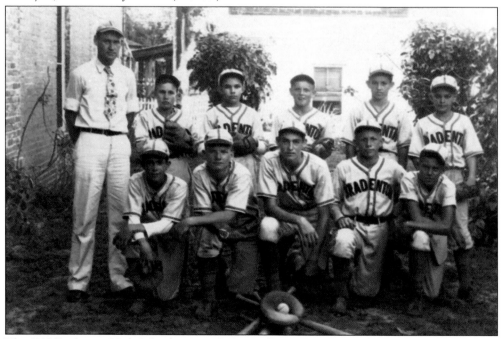

The 1939 Bradenton High School county champion baseball team included, in no particular order, Rowe Meade, Elwood Lovestead, John Scott, Leon Lockart, George DeLesline, C.W. Weldon, Jimmie Turner, Peter King, H.M. Willis, and coach James Hightower. (MCHS.)

After the completion of the Dixie Highway from Montreal to Miami in 1915, the number of automobile tourists increased dramatically. The opening allowed newly mobile people from around the nation to see the unique sites and communities of Florida's interior. The Tin Can Tourists of the World (TCT) was founded at a Tampa campground in 1919. Some say the origin of the term "tin can" referred to the campers' reliance upon canned foods. The emblem of the TCT was a tin can soldered to a radiator cap. The club held at least two meetings a year: a winter meeting at a campground in Florida and a summer meeting at a campground in Michigan. The Joseph Janney Steinmetz photograph at right shows John and Lizzie Wilson of Boston in Bradenton. Below, the TCT gathers in Bradenton. (Right, SLAF; below, MCHS.)

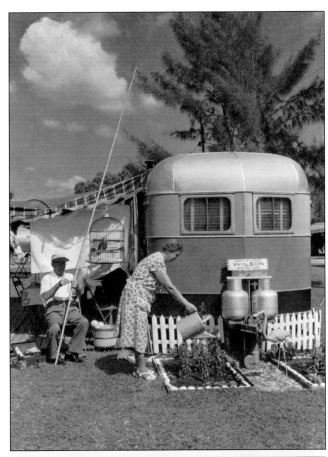

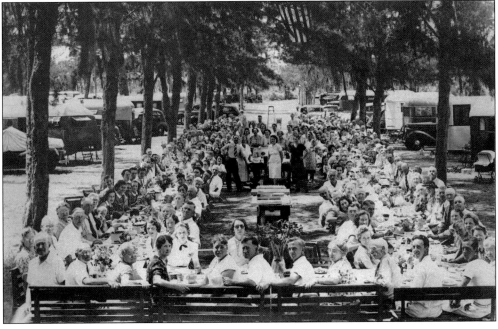

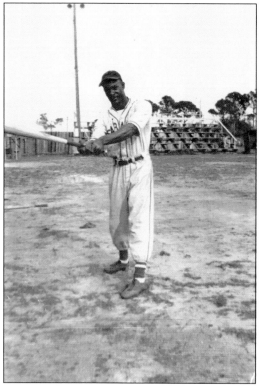

Before Jackie Robinson joined the Brooklyn Dodgers in 1947, black children who dreamed of playing professional baseball idolized players in the state and national Negro leagues, especially members of Bradenton's Nine Devils team. The team thrived from 1937 until 1956, when blacks were not permitted to integrate with white players. Consisting of players from Manatee and Sarasota Counties, the Nine Devils played between 70 and 75 games a year against both white and black ball clubs all over the state. Originally called the Braidentown Aces, they were renamed after winning their first nine games one season. They frequently drew a crowd to their home fields, McKechnie and Roush Parks. At left, Hugh Young Sr. prepares to "batter up." Below, members talk tactics. (Both, Sarasota Heritage House Museum.)

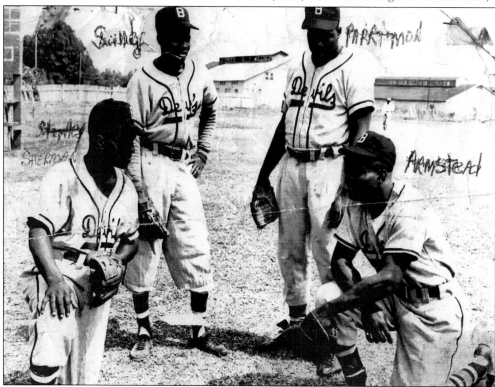

Around 1910, there were several other loosely structured outdoor-oriented youth organizations using the name Boy Scouts across the country. Records indicate that a troop formed on the corner of Ninth Street and Fourteenth Avenue in Bradentown in September 1910, making it the earliest documented troop in Florida. It was known as the Southwest Florida Council. Another troop formed in Manatee in June 1911. Troop No. 7 is seen here. (MCHS.)

The Bradenton beach pavilion and bathhouse was constructed in 1922 and cost about $30,000. Each side of the two-story main building had 100 locker facilities. The pavilion's center portion had a dance hall and dining room. Luxury apartments were on the second floor. Shortly after opening, it burned down and was rebuilt, this time at a cost of $40,000. It lasted for several years but burned again in 1929. (MCHS.)

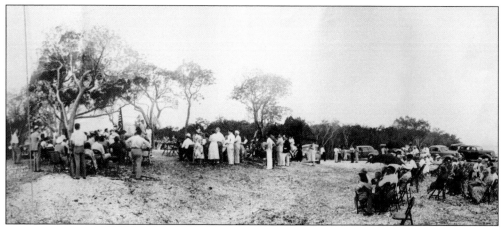

In 1934, Pres. Franklin D. Roosevelt appointed a commission to study the journals of the de Soto expedition and determine his exact landing point and route to Mississippi. The commission determined that it was Shaw's Point, which is now called Desoto Point. Here, people gathered for the dedication of the de Soto monument in 1939. (MCHS.)

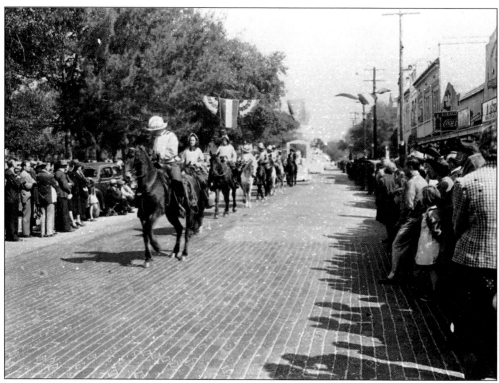

The Hernando de Soto Historical Society was formed in 1939. Members of the club don Spanish garb and make over 100 appearances annually. They also host the De Soto Heritage Festival each year in April, which culminates in a grand parade. In 1993, more than 150 Native Americans protested the parade to inform residents of de Soto's cruelty towards Florida's indigenous population. The 1948 parade is seen here. (MCHS.)

The original motto of the Bradentown Woman's Club was, "Be not simply good, be good for something." The club was formed in March 1913. In 1918, members purchased two lots on Ware's Creek at the corner of Manatee Avenue and Virginia Drive for $1,500. In 1921, construction of their clubhouse was completed, but there were no chairs, so a special meeting was called to collect chairs before the dedication ceremony. In this photograph, Woman's Club members celebrate the burning of the mortgage. (MCHS.)

In the early 1900s, businessmen in the community held a contest for the best walking advertisement. These young women pose in Fuller Park wearing their sponsors' advertisements. The *Bradenton Herald* is the only sponsor still in business. (MCHS.)

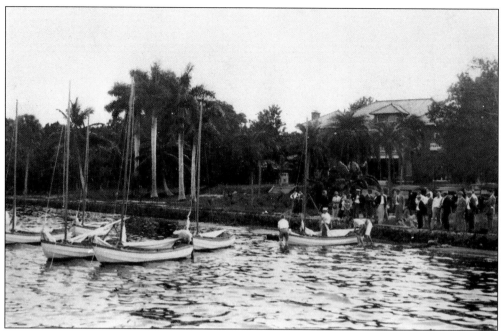

The first meeting of the Bradenton Yacht Club took place at Point Pleasant, where River Oaks Condominiums later stood. The Bradenton Yacht Club was chartered and incorporated on May 11, 1946, with 18 members. The club met at the Memorial Pier building. By 1960, membership had increased to 63, and members rented a building on a small basin west of the De Soto Bridge to accommodate the growth. In 1966, the club moved to Snead Island. (MCHS.)

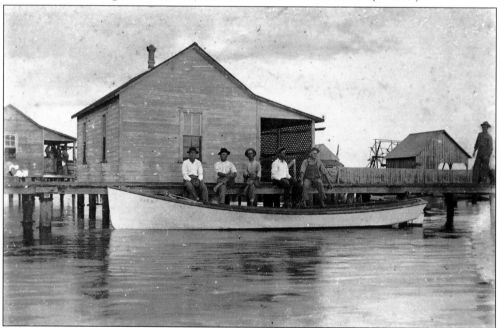

Jess Williams and a fishing crew sit on a dock near a boat in this photograph. Stilt houses, in the background, provided fishermen shelter from the sun and offered a place to rest and eat after a long day of casting and fishing. (MCHS.)

Records indicate that baseball began in Bradentown as early as 1908. The Fats and the Leans Team (below) was named for the various sizes of its players and was active from 1915 to 1917. McKechnie Field (above) opened in 1923 and was named for Bill McKechnie, a major league baseball great of the time. The commissioner of baseball, Kenesaw Mountain Landis, attended the field's opening ceremonies. He was flown in on a biplane that landed in the outfield and was piloted by Harry Land, a member of the Manatee County Board of Trade. In 1923, the grandstand sat 1,300, and 700 could easily occupy the bleachers, which included separate facilities for African American fans. The fairground buildings previously at the site were converted into makeshift locker rooms. The field is now the oldest stadium used for spring training and the second-oldest stadium used by a major league team. (Both, MCHS.)

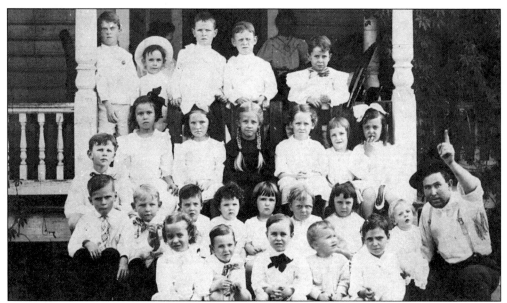

Attendees of Bob Turner's birthday party, seen here, included, from left to right, (first row) C.F. Owens, Bob Turner, Francis Rickelman, Burton Osborne, and Joe Schalze; (second row) Turner Clark, Clarence "Babe" Turner, Ralph Turner, Marian Curry, Eleanor Thomas, Rusie Wilhelm, Pauline Roesch, Raymond Turner, Eugene Turner, and Mr. Turner; (third row) Garland Turner, Lucy Edmundson, Emile Wilhelm, Gladys Osborne, Blanche Harvey, Lois Curry, and Margaret Owens; (fourth row) A.K. "Klein" Whitaker, Pat Stausfield, Byron Turner, Herman Turner, and Herman Burnett. (MCHS.)

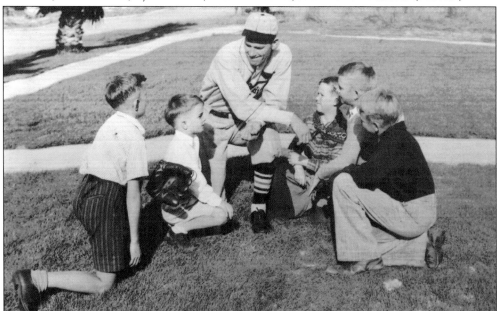

Here, Jay Hanna "Dizzy" Dean signs autographs for neighborhood children. Dean was one of the most beloved baseball characters in the area. Before he was sent to Bradenton for early spring training in 1930, he built up a large tab by taking his lady friends shopping on his St. Louis Cardinal expense account. While in Bradenton, he was put on a strict budget of only a dollar a day for his expenses; any more money was sure to get him in trouble. (Marianne Barneby.)

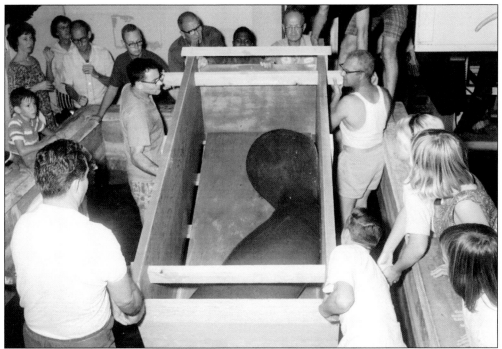

Born on July 21, 1948, at the Miami Tackle Company and Aquarium, Baby Snoots is considered the first manatee to be born in captivity. When he was a year old, Sam Stout, the owner of the facility, loaned him to Manatee County for the de Soto celebration. He was returned to Stout's floating aquarium on the *Prins Valdimir*. However, when Stout was suspected of capturing manatees illegally, he donated Baby Snoots to Bradenton. At first, the "sea cow" lived in a tank built inside the Chamber of Commerce Building at the pier (above). He became known as Snooty, and in 1966, he was moved to a 12-foot-by-20-foot tank at the newly constructed South Florida Museum (below). In 1979, he was officially named Manatee County's mascot. In 1993, he was transferred to his current location at the Parker Aquarium, within the South Florida Museum. He currently holds the record as the oldest captive manatee and the oldest known living manatee. (Both, MCHS.)

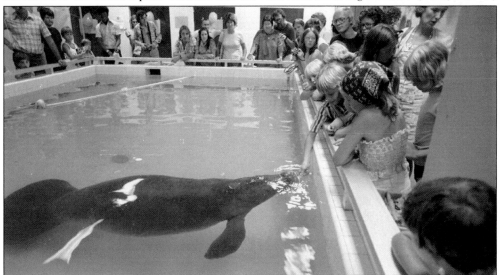

Discover Thousands of Local History Books Featuring Millions of Vintage Images

Arcadia Publishing, the leading local history publisher in the United States, is committed to making history accessible and meaningful through publishing books that celebrate and preserve the heritage of America's people and places.

Find more books like this at
www.arcadiapublishing.com

Search for your hometown history, your old stomping grounds, and even your favorite sports team.